THE FANTASTIC

A STRUCTURAL APPROACH
TO A LITERARY GENRE

TZVETAN TODOROV

Translated from the French
by RICHARD HOWARD

With a Foreword
by Robert Scholes

Cornell Paperbacks
CORNELL UNIVERSITY PRESS
ITHACA, NEW YORK

D1300433

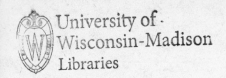

University of ·
Wisconsin-Madison
Libraries

International Standard Book Number 0-8014-9146-0
Library of Congress Catalog Card Number 74-10407

Printed in the United States of America

contents

foreword

A story is told of Todorov lecturing at an American university. (He lectures frequently in both French and English, though neither is his native language.) After one particular talk a professor of French commented on the clarity of his presentation, and he replied, "Oui, je sais, c'est là mon plus grand défaut." That lucidity can be seen as a fault—even in jest—suggests something interesting about the state of critical thought at present. We frequently confuse profundity with turgidity. All too often only what we fail to understand impresses us. Thus there is a certain rueful truth in Todorov's acknowledgment of the sin of clarity. He comes to our attention later than some structuralists whose prose approaches the impenetrable at times. And he is open to various kinds of critical rejoinders simply because we can understand fully what he is saying. *The Fantastic* is no exception. It is both lucid and provocative, inviting response and counterstatement. But before examining this book more directly, it will be well to consider Todorov himself and his place in the spectrum of critical activity.

Tzvetan Todorov was born in 1939 in Sofia, Bulgaria. His first academic degree was from the University of Sofia, with a major in Slavic philology, in 1961. In 1963 he arrived in Paris to pursue his graduate studies in language and literature, presenting a *Doctorat de troisiéme cycle* in 1966. His thesis, directed by Roland Barthes, was a study of the signifying systems of Choderlos de Laclos's epistolary novel, *Les Liaisons Dangereuses,* subsequently published by Larousse under the title *Littérature et Signification* (1967). Since 1968 he has been attached to the National Center for Scientific Research (CNRS) in Paris, presenting his *Doctorat d'État* in 1970. In the United States he has taught at Yale, Iowa, N.Y.U., Wisconsin, and Columbia, lecturing at many other universities as well. His major books since receiving his doctorat have been *Grammaire du Décaméron* (1969), *Introduction à la Littérature Fantastique* (1970), *Poétique de la Prose* (1971), *Dictionnaire Encyclopédique des Sciences du Langage* (with O. Ducrot, 1972), and *Poétique* (1973).

In 1970, with Hélène Cixous and Gerard Genette, Todorov founded *Poétique,* which has quickly become a major journal, publishing essays on poetics and literary theory written all over the world. In founding this journal the editors observed that a new awakening of the spirit of literary theory in France had predecessors and parallels in other countries, such as Anglo-American New Criticism, Russian formalism, and German *Literaturwissenschaft.* Rather than representing a school of literary criticism they wanted their journal to continue a tradition of studies in poetics extending from Aristotle to Valéry:

> We do not intend to make a fetish of the notion of literature, enclosing ourselves within the walls of a canonical definition. Literariness transcends the limits of "litera-

ture," and the poetic function extends beyond the field of "poetry." All play of language and writing, all rhetoric in action, every obliteration of verbal transparency, whether in folklore, in "mass communications," in the discourse of dream or madness, in the most modestly constructed texts or the most fortuitous encounters of words—all these enjoy full rights in the realm of modern poetics, which must be a poetics, above all, open. The practice of literary theory and analysis should not lead to the establishment of the existing tradition as a norm or the canonization of what has been accepted, but on the contrary should brighten the marginal or risky paths of the possible, and lighten the barriers in the way of works to come. The ambition of poetics is, in the strongest possible sense, to *give* something to reading—and thus, in a way, to writing. [From the editors' introduction to the first number of *Poétique* 1, 1970, pp. 1–2, unsigned but probably drafted by Genette, translated here by R.S.]

In this passage we can hear the accents of the Russian formalists and the Prague School: poetics deals with literariness, with the ways in which language reduces its transparency, calls attention to itself. But there is a contemporary note as well—that of the semioticians of the media and the advocates of the new novel. This paragraph begins like Roman Jakobson but ends like Roland Barthes. Its crucial idea is that poetics is a liberating discipline, freeing us from the stifling norms of our own age and the past, the desiccating piety that reduces texts to "classics" (squeezing the life out of them) and hinders our perception of the new unclassical or even anticlassical in literature. Poetics, we are told here, must serve to break down the barriers between the sacred fields of belles lettres and the profane marketplace of popular culture. Poetics can help us to see the literary quality in bumper stickers, or, conversely, the lack of literariness in the classics themselves. Poetics, truly understood, is a

liberation from prejudice, an opening of the mind, creating new opportunities for readers and writers.

It is this spirit, surely, which enables Todorov to approach with entire seriousness one of the humbler literary genres—the fantastic. Poetics, from Aristotle on, has concerned itself with genres as codifications of procedures and responses. A tragedy does this kind of thing to produce that kind of response. And this is precisely what we shall find Todorov doing in the present study, examining the codes shared by writer and reader that enable a certain kind of communication to take place. A literary text is a linguistic event—but an extraordinary one, with literary coding superimposed on the language itself. So say the structuralists and so said Aristotle, though not quite in the same words.

Can a study framed in this manner actually prove liberating? Doesn't generic investigation tend to move from description to prescription, ultimately closing more possibilities than it opens? These are important questions, to which Todorov addresses himself in this book, both explicitly and implicitly. But we all know how Aristotle's generic study became the basis for a most invidious kind of generic ranking, so it is legitimate for us to question whether a poetics can indeed be liberating in its ultimate effect. My own response is that it can, it must, and that the formalist/structuralist tradition shows us how this liberation is effected. Aristotle's generic system, like his world, was static. The formalists and their structuralist descendants, however, have given us the notion of literary types as forming in their aggregate an incomplete system, constantly seeking equilibrium but always disturbed by new cultural intrusions from beyond the world of letters itself. Thus genres persist like any convenient codification of cultural behavior but come into periods of fruition and dominance when most responsive to other cultural needs—only to harden, to atrophy, and

be replaced by others. This incomplete system offers freedom for the writer, because no genre is itself ever complete—it is modified, as Todorov suggests, by each new work of imagination—and because the system itself is always open, with weak or neglected genres offering increasingly attractive possibilities for writers driven to "make it new." A responsible poetics, as the editors of *Poétique* suggested, must function to lubricate this generic flux, to encourage in readers a freedom that comes from understanding, offering writers audiences that are sophisticated about literary coding but unprejudiced about the value of particular codes.

Todorov himself, in *The Fantastic,* seeks to examine both generic theory and a particular genre, moving back and forth between a poetics of the fantastic itself and a metapoetics or theory of theorizing, even as he suggests that one must, as a critic, move back and forth between theory and history, between idea and fact. His work on the fantastic is indeed about a historical phenomenon that we recognize, about specific works that we may read, but it is also about the use and abuse of generic theory. For a poetician, as for any scientist, every instance is an example, every item belongs to a class. And no matter how much we long for uniqueness, whether personal or literary, we must finally acknowledge that we cannot even recognize uniqueness except as a deviation from some norm. A world of unique objects would not only be overwhelming and intolerable; it would not even be perceptible.

Though he has been called Mr. Structuralism, Todorov is a poetician first and a structuralist second, and the latter only in order to be the former. For him, the two terms are almost synonymous. A study he wrote for a volume called *Qu'est-ce que le structuralisme?* has been reprinted (substantially revised) under the simple title *Poétique.* Perhaps the best name, then, for the critical

work done by Todorov (or his colleague Genette) is structural poetics. The noun dominates. But the adjective alerts us to certain special features. Structural poetics is the modern phase of a traditional discipline. To an essentially Aristotelian attitude is added a view of language derived from Ferdinand de Saussure and Roman Jakobson, and a view of literature derived from the Russian formalists. The leading structural poeticians of fiction at the present time include Boris Uspensky in Russia, Claudio Guillén in Spain (and the United States), Todorov and Genette in France. All of these men are consciously working in a tradition that draws upon Russian formalism but acknowledges and includes the contributions of Henry James and his Anglo-American descendants in the field of fictional poetics, including the Chicago critics, with whom they share Aristotle as a common ancestor. What links contemporary critics as disparate as Guillén, Wayne Booth, and these French poeticians is a common concern for literary genres as fundamental to our perception of fiction (though in Booth the emphasis is on what happens when we lose generic assurance). A "science of criticism" may or may not exist, but there is a body of critics whose goals and methods are similar enough so that a genuinely international and comparative criticism of fiction is becoming possible. The poeticians are making a major contribution here, and Todorov is among the leaders.

As an essay in fictional poetics *The Fantastic* is consciously structuralist in its approach to its generic subject. Todorov seeks linguistic bases for the structural features he notes in fantastic texts. He strives in his methodology for a rigor and system that approach the scientific. Thus he raises for us the vexed questions whether literary study can or should aspire to scientific standards of exactness and consensus. For him, these questions must be answered in the affirmative. To justify its own existence,

poetics must be a science, since what cannot be "known" is impossible really to study or to teach. Northrop Frye, it will no doubt be remembered, took a similar position in his *Anatomy of Criticism.* Thus, it is especially interesting to find Todorov opening *The Fantastic* with a polemical introduction that calls into question Frye's achievement in the poetics of fictional modes and genres. Frye calls for science but hardly tries to give it to us, is the charge made here, and it is a serious charge, vigorously maintained.

Still, no scientific method works well for anyone who is not a good scientist. If Todorov were not gifted with a high order of analytic and synthetic ability we would not be reading him. Furthermore, neither structuralism itself nor poetics in general is noted for its ability to charm readers. Yet this essay in structural poetics—even though Richard Howard has emphasized in his translation a mechanical quality in Todorov's French prose—is a very engaging book. This is structuralism at play, generating its own rigorous games, like a young computer on a holiday. The result is genuinely pleasing. Also formidable. No student of fictional poetics, nor anyone interested in fantastic literature, will want to miss it.

Robert Scholes

Brown University

the fantastic

les genres littéraires

1

literary genres

"The Fantastic" is a name given to a kind of literature, to a literary genre. When we examine works of literature from the perspective of genre, we engage in a very particular enterprise: we discover a principle operative in a number of texts, rather than what is specific about each of them. To study Balzac's *The Magic Skin* in the context of the fantastic as a genre is quite different from studying this book in and of itself, or in the canon of Balzac's works, or in that of contemporary literature. Thus the concept of genre is fundamental to the discussion which follows, and we must first clarify and define it, even if such an endeavor apparently diverts us from the fantastic itself.

The notion of genre immediately raises several questions; fortunately, some of these vanish once we have formulated them explicitly. The first question is: are we entitled to discuss a genre without having studied (or at least read) all the works which constitute it? The graduate student who asks this question might add that a catalogue of the fantastic would include thousands of titles. Whence it is only a step to the image of the diligent student buried under books he must read at the rate of three a day, obsessed by the idea that new ones keep being written and that he will doubtless never manage

to absorb them all. But one of the first characteristics of scientific method is that it does not require us to observe every instance of a phenomenon in order to describe it; scientific method proceeds rather by deduction. We actually deal with a relatively limited number of cases, from them we deduce a general hypothesis, and we verify this hypothesis by other cases, correcting (or rejecting) it as need be. Whatever the number of phenomena (of literary works, in this case) studied, we are never justified in extrapolating universal laws from them; it is not the quantity of observations, but the logical coherence of a theory that finally matters. As Karl Popper writes:

> It is far from obvious, from a logical point of view, that we are justified in inferring universal statements from singular ones, no matter how numerous; for any conclusion drawn in this way may always turn out to be false: no matter how many instances of white swans we have observed, this does not justify the conclusion that all swans are white.

On the other hand, a hypothesis which is based on the observation of a limited number of swans but which also informs us that their whiteness is the consequence of an organic characteristic would be perfectly legitimate. To return from swans to novels, this general scientific truth applies not only to the study of genres, but also to that of a writer's entire *oeuvre,* or to that of a specific period, etc. Let us leave exhaustiveness, then, to those who have no other recourse.

The level of generality on which a genre is to be located raises a second question. Are there only a few genres (i.e., lyric, epic, dramatic), or many more? Are genres finite in number or infinite? The Russian formalists tended toward a relativist answer. According to Tomashevsky:

> Works are divided into large classes which are subdivided into types and species. In this way, moving down the ladder of genres, we move from abstract classes to concrete historical distinctions

(the poem by Byron, the short story by Chekhov, the novel by Balzac, the religious ode, proletarian poetry) and even to specific works.

This passage certainly raises more problems than it solves, and we shall return to it shortly: but we may already accept the idea that genres exist at different levels of generality, and that the content of this notion is defined by the point of view we have chosen.

A third problem is a matter of aesthetics. We are told that it is pointless to speak of genres (tragedy, comedy, etc.), for the work of art is essentially unique, valuable because of what is original about it that distinguishes it from all other works, and not because of whatever in it may resemble them. If I like *The Charterhouse of Parma*, I do so not because it is a novel (genre) but because it is a novel different from all other novels (an individual work). This response implies a romantic attitude with regard to the material under observation. Such a position is not, strictly speaking, false; it is simply extraneous. We may certainly like a work for one reason or another; this is not what defines it as an object of study. The motive of an intellectual enterprise need not dictate the form which that enterprise ultimately assumes. As for the aesthetic problem in general, it will not be dealt with here: not because it does not exist, but because it far exceeds our present means.

However, this same objection can be formulated in different terms, whereupon it becomes much more difficult to refute. The concept of genre (or species) is borrowed from the natural sciences. It is no accident, moreover, that the pioneer structural analyst of narrative, Vladimir Propp, employed analogies with botany or zoology. Now there is a qualitative difference as to the meanings of the terms "genre" and "specimen," depending on whether they are applied to natural beings or to works of the mind. In the former case, the appearance of a new example does not necessarily modify the characteris-

tics of the species; consequently, the properties of the new example are for the most part entirely deducible from the pattern of the species. Being familiar with the species tiger, we can deduce from it the properties of each individual tiger; the birth of a new tiger does not modify the species in its definition. The impact of individual organisms on the evolution of the species is so slow that we can discount it in practice. Similarly in the case of linguistic utterances (though to a lesser degree): an individual sentence does not modify the grammar of the language, and the grammar must permit us to deduce the properties of the sentence.

The same is not the case in the realm of art or of science. Here evolution operates with an altogether different rhythm: *every* work modifies the sum of possible works, each new example alters the species. We might say that in art we are dealing with a language of which every utterance is agrammatical at the moment of its performance. More exactly, we grant a text the right to figure in the history of literature or of science only insofar as it produces a change in our previous notion of the one activity or the other. Texts that do not fulfill this condition automatically pass into another category: that of so-called "popular" or "mass" literature in the one case; in the other, that of the academic exercise or unoriginal experiment. (Hence the unavoidable comparison of the artisanal product, the unique example, on the one hand, and of mass production, the mechanical stereotype, on the other.) To return to our subject, only "popular" literature (detective stories, serialized novels, science fiction, etc.) would approach fulfilling the requirements of genre in the sense the word has in natural science; for the notion of genre in that sense would be inapplicable to strictly literary texts.

Such a position obliges us to make our own theoretical assumptions explicit. Dealing with any text belonging to "literature," we must take into account a double requirement. First, we must be aware that it manifests properties that it shares with all literary texts, or with texts belonging to one

of the sub-groups of literature (which we call, precisely, genres). It is inconceivable, nowadays, to defend the thesis that everything in the work is individual, a brand-new product of personal inspiration, a creation with no relation to works of the past. Second, we must understand that a text is not only the product of a pre-existing combinatorial system (constituted by all that is literature *in posse*); it is also a transformation of that system.

We can already say, then, that every literary study must participate in a double movement: from the particular work to literature generally (or genre), and from literature generally (from genre) to the particular work. To grant a temporary privilege to one direction or the other — to difference or to resemblance — is a perfectly legitimate transaction. Further, it is of the very nature of language to move within abstraction and within the "generic." The individual cannot exist *in* language, and our formulation of a text's specificity automatically becomes the description of a genre, whose particular characteristic is that the work in question is its first and unique example. Any description of a text, by the very fact that it is made by means of words, is a description of genre. Moreover, this is not a purely theoretical assertion; we are repeatedly given examples by literary history, whenever epigones imitate precisely what was specific in the initiator.

There can therefore be no question of "rejecting the notion of genre," as Croce, for example, called for. Such a rejection would imply the renunciation of language and could not, by definition, be formulated. It is important, on the other hand, to be aware of the degree of abstraction that one assumes, and of the position of this abstraction with regard to any real development; such development will thereby be kept within a system of categories which establish and at the same time depend on it.

The fact remains that literature now seems to be abandoning the division into genres. Over a decade ago, Maurice Blanchot wrote:

Only the book matters, as it stands, far from genres, apart from
the labels — prose, poetry, novel, reportage — by which it refuses
to be categorized and to which it denies the power to assign its
place and determine its form. A book no longer belongs to a
genre, every book proceeds only from literature, as if literature
held in advance, in their generality, the secrets and formulas which
alone permit giving what is written the reality of a book [*Le
Livre à Venir*].

Why then raise these outdated problems? Gérard Genette
has answered perfectly: "Literary discourse is produced and
developed according to structures it can transgress only
because it finds them, even today, in the field of its language
and style" (*Figures,* II). For there to be a transgression, the
norm must be apparent. Moreover, it is doubtful that contem-
porary literature is entirely exempt from generic distinctions;
it is only that these distinctions no longer correspond to the
notions bequeathed by the literary theories of the past. We
are of course not obliged to abide by such notions now; indeed
there is a growing necessity to elaborate abstract categories
that could be applied to contemporary work. More generally,
failing to recognize the existence of genres is equivalent to
claiming that a literary work does not bear any relationship
to already existing works. Genres are precisely those relay-
points by which the work assumes a relation with the universe
of literature.

In order to take a step forward, let us select a contempo-
rary theory of genres for closer scrutiny. Thus, starting from
a single model, we can get a better sense of what positive
principles must guide our work, what dangers are to be
avoided. Which is not to say that new principles will not arise
from our own discourse, as we proceed, or that unsuspected
obstacles will not appear at many points.

The theory of genres to be discussed in detail here is
that of Northrop Frye, especially as it is formulated in his
Anatomy of Criticism. Nor is this choice arbitrary: Frye today
occupies a preeminent place among Anglo-American critics,

and his book is undoubtedly one of the most remarkable works of criticism published since the Second World War. *Anatomy of Criticism* is at once a theory of literature (and therefore of genres) and a theory of criticism. More precisely, this book is composed of two kinds of texts, one of a theoretical order (the introduction, the conclusion, and the second essay: "Ethical Criticism: Theory of Symbols"), the other, more descriptive, in which Frye sets forth his system of genres. But in order to be understood, this system cannot be isolated from the whole; therefore we shall begin with the theoretical part.

Here are its chief characteristics:

1. Literary studies are to be undertaken with the same seriousness, the same rigor evinced by the other sciences:

> If criticism exists, it must be an examination of literature in terms of a conceptual framework derivable from an inductive survey of the literary field. . . . There may be a scientific element in criticism which distinguishes it from literary parasitism on the one hand, and the superimposed critical attitude on the other.

2. A consequence of this first postulate is the necessity of removing from literary study any value judgment concerning the works in question. Frye is quite severe on this point. We may ease his verdict and say that evaluation will have its place in the field of poetics, but that for the moment to refer to evaluation would be to complicate matters to no purpose.

3. The literary work, like literature in general, forms a system; nothing in it is due to chance. Or as Frye puts it: "The first postulate of this inductive leap is the same as that of any science: the assumption of total coherence."

4. Synchrony is to be distinguished from diachrony: literary analysis requires us to take synchronic soundings in history, and it is within these that we must *begin* by seeking the system. As Frye writes in *Fables of Identity*, "When a critic deals with a work of literature, the most natural thing

for him to do is to freeze it, to ignore its movement in time and look at it as a completed pattern of words, with all its parts existing simultaneously."

5. The literary text does not enter into a referential relation with the "world," as the sentences of everyday speech often do; it is not "representative" of anything but itself. In this, literature resembles mathematics rather than ordinary language: literary discourse cannot be true or false, it can only be valid in relation to its own premises. "The poet, like the pure mathematician, depends not on descriptive truth, but on conformity to his hypothetical postulates.... Literature, like mathematics, is a language, and a language in itself represents no truth, though it may provide the means for expressing any number of them." Thus the literary text participates in tautology: it signifies itself: "the poetic symbol means primarily itself in relation to the poem." The poet's answer as to what any element of his work means must always be: "I meant it to form a part of the play."

6. Literature is created from literature, not from reality, whether that reality is material or psychic; every literary work is a matter of convention. "Poetry can only be made out of other poems, novels out of other novels. Literature shapes itself and is not shaped externally.... Everything that is new in literature is a reworking of what is old.... Self-expression in literature is something which has never existed."

None of these ideas is entirely original (though Frye rarely gives his sources): they can be found on the one hand in Mallarmé or Valéry, as well as in a tendency of contemporary French criticism which continues their tradition (Blanchot, Barthes, Genette); on the other hand, very abundantly, in the Russian formalists; and finally in authors such as T.S. Eliot. The sum of these postulates, as valid for literary studies as for literature itself, constitutes our own point of departure. But all this has taken us quite far from genres. Let us turn to the part of Frye's book which interests us more directly. Throughout the *Anatomy* (which consists, we must recall,

of texts which first appeared separately), Frye proposes several sets of categories, all of which can be subdivided into genres (though Frye applies the term "genre" to only one of these sets). I do not intend to discuss them in detail here. Concentrating on a purely methodological discussion, I shall retain only the logical articulation of his classifications without giving his examples.

1. The first classification defines the "modes of fiction." They are constituted by the relation between the hero of the work and ourselves or the laws of nature, and are five in number:

i The hero is by *nature* superior to the reader *and* to the laws of nature; this genre is called *myth*.

ii The hero is by *degree* superior to the reader *and* to the laws of nature; this genre is that of *legend* or *fairy tale*.

iii The hero is by *degree* superior to the reader *but not* to the laws of nature; this is the *high mimetic genre*.

iv The hero is *on a basis of equality with* the reader *and* the laws of nature; this is the *low mimetic genre*.

v The hero is *inferior to* the reader; this is the genre of *irony*.

2. Another fundamental category is that of verisimilitude. The two poles of literature are here constituted by the plausible narrative and the narrative whose characters can do anything.

3. A third category emphasizes two principal tendencies of literature: the comic, which reconciles the hero with society; and the tragic, which isolates him from it.

4. The classification which appears to be most important for Frye is the one which defines the archetypes. There are four of these (four *mythoi*, to use a term Frye employs as a synonym for "archetypes"), based on the opposition of

the real and the ideal. Thus Frye characterizes *romance* (based on the ideal), *irony* (based on reality), comedy (which involves a transition from reality to the ideal), and tragedy (which involves a transition from the ideal to reality).

5. Next comes the division into genres strictly speaking, based on the type of audience for which the works are intended. The genres are: *drama* (works to be performed), *lyric poetry* (works to be sung), epic poetry (works to be recited), prose (works to be read). To which is added the following specification: "The chief distinction is involved with the fact that *epos* is episodic and fiction continuous."

6. A final classification is articulated in terms of oppositions between intellectual and personal, introvert and extrovert, and may be presented schematically as follows:

	intellectual	*personal*
introvert	confession	romance
extrovert	anatomy	novel

These are some of the categories (we may also say, some of the genres) proposed by Frye. His boldness is apparent and praiseworthy; it remains to be seen what it contributes.

I

The first remarks we shall formulate, and the easiest, are based on logic, if not on common sense (their usefulness for the study of the fantastic will appear, it is to be hoped, later on). Frye's classifications are not logically coherent, either among themselves or individually. In his critique of Frye, Wimsatt had already, and justifiably, pointed out the impossibility of coordinating the two chief classifications, the

first and the fourth summarized above. As for the internal inconsistencies, they appear as soon as we make even cursory analysis of the first classification.

In that classification, a unit, the hero, is compared both with the reader ("ourselves") and with the laws of nature. The relation (of superiority), moreover, can be either qualitative (of nature) or quantitative (of degree). But by schematizing this classification, we discover that many possible combinations are missing from Frye's enumeration. Let us say straight off that there is an asymmetry: only one category of inferiority corresponds to the three categories of the hero's superiority; further, the distinction of nature as opposed to degree is applied only once, whereas we might produce it apropos of each category. Doubtless we might avoid the reproach of incoherence by postulating additional restrictions which would reduce the number of possibilities. For example, we could say that the relation of the hero to the laws of nature functions between a whole and an element, not between two elements: if the hero obeys these laws, there can no longer be a question of difference between quality and quantity. In the same way, we could specify that if the hero is inferior to the laws of nature, he can be superior to the reader, but that the converse is not true. These additional restrictions would permit us to avoid inconsistencies: but it is absolutely necessary to formulate them; otherwise we are employing a system which is not explicit and we remain in the realm of faith — unless it is the realm of superstitions.

An objection to our own objections might be: if Frye enumerates only five genres (modes) out of the thirteen possibilities that are theoretically available, it is because these five genres have existed, which is not true of the eight others. This remark leads to an important distinction between two meanings given to the word genre. In order to avoid all ambiguity, we should posit, on the one hand, *historical genres*; on the other, *theoretical genres*. The first would result from an observation of literary reality; the second from a deduction

of a theoretical order. What we learn in school about genres always relates to historical genres: we are told about classical tragedy because there have been, in France, works which manifested their relation to this literary form. We find examples of theoretical genres, on the other hand, in works of the ancient writers on poetics. Thus Diomedes, in the fourth century, follows Plato in dividing all works into three categories: those in which only the narrator speaks; those in which only the characters speak; and those in which both speak. This classification is not based on a comparison of works to be found in the history of literature (as in the case of historical genres), but on an abstract hypothesis which postulates that the performer of the speech act is the most important element of the literary work, and that according to the nature of this performer, we can distinguish a logically calculable number of theoretical genres. Lessing proceeds in the same fashion when he "calculates" in advance the sub-genres of the epigram, which consists, he asserts, of an expectation and an explanation: "Of course there may be only two sub-genres of the epigram, the first, which awakens expectation without affording a solution; the second, which affords the solution without having created expectations."

Now Frye's system, like that of the ancient writers or Lessing's, is composed of *theoretical* genres and not historical ones. There are a certain number of genres not because more have not been observed, but because the principle of the system imposes that number. It is therefore necessary to deduce all the possible combinations from the categories chosen. We might even say that if one of these combinations had in fact never been manifested, we should describe it even more deliberately: just as in Mendeleev's system one could describe the properties of elements not yet discovered, similarly we shall describe here the properties of genres — and therefore of works — still to come.

To this first observation, we may add two other remarks. First, any theory of genres is based on a conception of the

work, on an image of the work, which involves on one hand a certain number of abstract properties, on the other a certain number of laws governing the relation of these properties. If Diomedes divides genres into three categories, it is because he postulates, within the work, a certain feature: the existence of a performer of the speech act; furthermore, by basing his classification on this feature, he testifies to the primary importance he grants it. Similarly, if Frye bases his classification on the relation of superiority or inferiority between the hero and ourselves, it is because he regards this relation as an element of the work and, further, as one of its fundamental elements.

We may, to proceed a step further, introduce an additional distinction within the theoretical genres, and speak of *elementary genres* and *complex* ones. The first would be defined by the presence or absence of a single characteristic, as in Diomedes; the second, by the coexistence of several characteristics. For instance, we might define the complex genre "sonnet" as uniting the following properties: (1) certain prescriptions as to rhymes; (2) certain prescriptions as to meter; (3) certain prescriptions as to theme. Such a definition presupposes a theory of meter, of rhyme, and of themes (in other words, a total theory of literature). It thus becomes obvious that historical genres form a part of the complex theoretical genres.

II

By noting certain formal incoherences in Frye's classifications, we have already been led to an observation which no longer bears on the logical form of his categories but on their content. Frye never makes explicit his conception of the work (which, as we have seen, must serve as the point of departure for any classification into genres) and he devotes remarkably

few pages to the theoretical discussion of his categories. Let us attempt to do so in his place.

First let us enumerate some of them: superior/inferior; verisimilitude/fantasy; reconciliation/exclusion (in relation to society); real/ideal; introvert/extrovert; intellectual/personal. What is striking in this list from the very first is its arbitrariness: why are these categories and not others useful in describing a literary text? One looks for a closely reasoned argument which would prove this importance; but there is no trace of such an argument. Further, we cannot fail to notice a characteristic common to these categories: their non-literary nature. They are all borrowed from philosophy, from psychology, or from a social ethic, and moreover not from just any psychology or philosophy. Either these terms are to be taken in a special, strictly literary sense; or — and since we are told nothing about such a sense, this is the only possibility available to us — they lead us outside of literature. Whereupon literature becomes no more than a means of expressing philosophical categories. Its autonomy is thus profoundly contested — and we again contradict one of the theoretical principles stated, precisely, by Frye himself.

Even if these categories applied only to literature, they would require a more extended explanation. Can we speak of the hero as if this notion were self-explanatory? What is the precise meaning of this word? And what is verisimilitude? Is its contrary (fantasy) only the property of stories in which the characters "can do anything"? Frye himself, moreover, gives another interpretation of verisimilitude which contests this first sense of the word: "An original painter knows, of course, that when the public demands likeness to an object, it generally wants the exact opposite, likeness to the pictorial conventions it is familiar with."

III

When we press Frye's analyses still more closely, we discover another postulate which, though unformulated, plays a leading role in his system. The points we have hitherto criticized could be readily accommodated without altering the system itself: we could avoid the logical incoherences and find a theoretical basis for the choice of categories. The consequences of this new postulate are much more serious, for it involves a fundamental option, the very one by which Frye clearly opposes the structuralist attitude, attaching himself instead to a tradition that includes such names as Jung, Gaston Bachelard, Gilbert Durand (however different their works).

This is the postulate: the *structures* formed by literary phenomena *manifest themselves at the level of these phenomena* — i.e., these structures are directly observable. Lévi-Strauss writes, on the contrary: "The fundamental principle is that the notion of social structure is not related to empirical reality but to the model constructed according to that reality." To simplify, we might say that in Frye's view, the forest and the sea form an elementary structure; for a structuralist, on the contrary, these two phenomena manifest an abstract structure which is a mental construction and which sets in opposition, let us say, the static and the dynamic. Hence we see why certain images such as the four seasons, or the four times of day, or the four elements play such an important role for Frye: as he himself asserts in his preface to a translation of Bachelard: "earth, air, fire, and water are still the four elements of imaginative experience, and always will be." While the "structure" of the structuralists is above all an abstract principle or rule, Frye's "structure" is reduced to an arrangement in space. Frye is explicit on the point: "Very often a 'structure' or 'system' of thought can be reduced to a diagrammatic pattern — in fact both words are to some extent synonyms of diagram."

A postulate has no need of proofs; but its effectiveness can be measured by the results we reach by accepting it. Since the formal organization cannot be apprehended, we believe, on the level of the images themselves, all that we can say about the latter will remain only approximative. We must be content with probabilities, instead of dealing with certainties and impossibilities. To return to our example of the most elementary kind, the forest and the sea *can* often be found in opposition, thus forming a "structure"; but they do not *have to*; while the static and the dynamic necessarily form an opposition, which can be manifested in that of the forest and the sea. Literary structures are so many systems of rigorous rules, and it is only their manifestations which conform to probabilities. If we seek the structures on the level of the observable images, we thereby refuse all certain knowledge.

This is certainly what happens in Frye's case. One of the words most often encountered in the *Anatomy* is surely the word *often* and its synonyms. Some examples:

> This myth is *often* associated with a flood, the regular symbol of the beginning and the end of a cycle. . . . The infant hero is *often* placed in an ark *or* chest floating on the sea. . . . On dry land the infant *may* be rescued *either* from *or* by an animal. . . . Its *most common* settings are the mountaintop, the island, the tower, the lighthouse, and the ladder or staircase. . . . He *may* also be a ghost, like Hamlet's father; *or* it *may* not be a person at all, but simply an invisible force known only by its effects. . . . *Often,* as in the revenge-tragedy, it is an event previous to the action of which the tragedy itself is the consequence [my italics].

The postulate of a direct manifestation of structures produces a sterilizing effect in several other directions. First we must remark that Frye's hypothesis cannot go further than a taxonomy, a classification (according to his explicit declarations). But to say that the elements of a whole can be classified

3. The concept of genre must be qualified. We have set in opposition, on the one hand, historical and theoretical genres: historical genres are the result of an observation of literary phenomena; theoretical genres are deduced from a theory of literature. Further, we have distinguished, within theoretical genres, between elementary and complex genres: the former are characterized by the presence or absence of a single structural feature; the latter by the presence or absence of a conjunction of such features. Everything suggests that historical genres are a sub-group of complex theoretical genres.

Abandoning now the analyses by Frye which have guided us thus far, we must finally, with their help, formulate a more general and more cautious view of the objectives and limits of any study of genres. Such a study must constantly satisfy requirements of two orders: practical and theoretical, empirical and abstract. The genres we deduce from the theory must be verified by reference to the texts: if our deductions fail to correspond to any work, we are on a false trail. On the other hand, the genres which we encounter in literary history must be subject to the explanation of a coherent theory; otherwise, we remain imprisoned by prejudices transmitted from century to century, and according to which (an imaginary example) there exists a genre such as comedy, which is in fact a pure illusion. The definition of genres will therefore be a continual oscillation between the description of phenomena and abstract theory.

Such are our objectives; but upon closer inspection, we cannot help doubting the success of the enterprise. Consider the first requirement, that of the conformity of the theory to the phenomena. We have postulated that literary structures, hence genres themselves, be located on an abstract level, separate from that of concrete works. We would have to say that a given work manifests a certain genre, not that this genre exists in the work. But this relation of manifestation between

But in Chinese, where titles are often added after the fact & post facto and anthologies followed precedental divisions — this is a special problem.

the abstract and the concrete is of a probabilistic nature; in other words, there is no necessity that a work faithfully incarnate its genre, there is only a probability that it will do so. Which comes down to saying that no observation of works can strictly confirm or invalidate a theory of genres. If I am told: a certain work does not fit any of your categories, hence your categories are wrong, I could object: your "hence" has no reason to exist: works need not coincide with categories, which have merely a constructed existence; a work can, for example, manifest more than one category, more than one genre. We are thus led to an exemplary methodological impasse: how to prove the descriptive failure of any theory of genres whatever? The reproach we made to Frye appears to apply to any work, ours included.

Consider now the other side, the conformity of known genres to theory. The theoretical test will be no easier than the empirical one. The danger is nonetheless of a different nature: it is that our categories will tend to lead us outside of literature. Every theory of literary themes, for example (up till now, in any case), tends to reduce these themes to a complex of categories borrowed from psychology or philosophy or sociology (witness Frye). Were these categories to be borrowed from linguistics, the situation would not be qualitatively different. Further: by the very fact that we must use ordinary language in order to speak of literature, we imply that literature transmits something which could be designated by other means. But if this were true, why should literature exist at all? Its only reason for being is that it says what non-literary language does not and cannot say. Therefore some of the best critics tend to become writers themselves in order to avoid the violence wrought upon literature by non-literature; but it is a hopeless effort. A new literary work has been created, the previous one has not been matched. Literature says what it alone can say. When the critic has said everything in his power about a literary text, he has still said nothing; for the

very existence of literature implies that it cannot be replaced by non-literature.

These skeptical reflections need not discourage us; they merely oblige us to become aware of limits we cannot transcend. The goal of knowledge is an approximative truth, not an absolute one. If descriptive science claimed to speak *the* truth, it would contradict its reason for being. (Indeed, a certain form of physical geography no longer exists since all the continents have been correctly described.) Imperfection is, paradoxically, a guarantee of survival.

2

definition of the fantastic

Alvaro, the main character of Cazotte's tale *Le Diable Amoureux*, lives for two months with a female being whom he believes to be an evil spirit: the devil or one of his henchmen. The way this being first appeared clearly suggests that she is a representative of the other world. But her specifically human (and, what is more, feminine) behavior, and the real wounds she receives, seem, on the contrary, to prove that she is simply a woman, and a woman in love. When Alvaro asks where she comes from, Biondetta replies: "I am a sylphide by birth, and one of the most powerful among them. . . ." But do sylphides exist? ("I could make nothing of these words," Alvaro continues. "But what could I make of my entire adventure? It all seems a dream, I kept telling myself; but what else is human life? I am dreaming more extravagantly than other men, that is all. . . . What is possible? What is impossible?")

Thus Alvaro hesitates, wonders (and the reader with him) whether what is happening to him is real, if what surrounds him is indeed reality (in which case sylphides exist), or whether it is no more than an illusion, which here assumes the form of a dream. Alvaro is later induced to sleep with

this very woman who *may* be the devil; and, alarmed by this eventuality, he questions himself once more: "Have I been asleep? Is it my fortune that all this has been no more than a dream?" His mother will reflect in the same fashion: "You have dreamed this farm and all its inhabitants." The ambiguity is sustained to the very end of the adventure: reality or dream? truth or illusion?

Which brings us to the very heart of the fantastic. In a world which is indeed our world, the one we know, a world without devils, sylphides, or vampires, there occurs an event which cannot be explained by the laws of this same familiar world. The person who experiences the event must opt for one of two possible solutions: either he is the victim of an illusion of the senses, of a product of the imagination — and laws of the world then remain what they are; or else the event has indeed taken place, it is an integral part of reality — but then this reality is controlled by laws unknown to us. Either the devil is an illusion, an imaginary being; or else he really exists, precisely like other living beings — with this reservation, that we encounter him infrequently.

The fantastic occupies the duration of this uncertainty. Once we choose one answer or the other, we leave the fantastic for a neighboring genre, the uncanny or the marvelous. The fantastic is that hesitation experienced by a person who knows only the laws of nature, confronting an apparently supernatural event.

The concept of the fantastic is therefore to be defined in relation to those of the real and the imaginary: and the latter deserve more than a mere mention. But we shall postpone their discussion for the last chapter of our study.

Is such a definition at least an original one? We may find it, though formulated differently, in the nineteenth century. First of all, in the work of the Russian philosopher and mystic Vladimir Solovyov: "In the genuine fantastic, there

is always the external and formal possibility of a simple explanation of phenomena, but at the same time this explanation is completely stripped of internal probability." There is an uncanny phenomenon which we can explain in two fashions, by types of natural causes and supernatural causes. The possibility of a hesitation between the two creates the fantastic effect.

Some years later M. R. James, a British author specializing in ghost stories, adopted virtually the same terms: "It is sometimes necessary to keep a loophole for a natural explanation, but I might add that this hole should be small enough to be unusable." Once again, then, two solutions are possible.

Here is a more recent German example: "The hero continually and distinctly feels the contradiction between two worlds, that of the real and that of the fantastic, and is himself amazed by the extraordinary phenomena which surround him" (Olga Riemann). We might extend this list indefinitely. Yet let us note a difference between the first two definitions and the third: in the former, it is the reader who hesitates between the two possibilities; in the latter, it is the character; we shall return to this difference.

It must further be noted that recent French definitions of the fantastic, if they are not identical with ours, do not on the other hand contradict it. We shall give a few examples drawn from the "canonical" texts on the subject. Castex, in *Le Conte Fantastique en France*, writes: "The fantastic. . . is characterized . . .by a brutal intrusion of mystery into the context of real life." Louis Vax, in *L' Art et la Littérature Fantastiques*: "The fantastic narrative generally describes men like ourselves, inhabiting the real world, suddenly confronted by the inexplicable." Roger Caillois, in *Au Coeur du Fantastique*: "The fantastic is always a break in the acknowledged order, an irruption of the inadmissible within the changeless everyday legality."

These definitions are all included within the one proposed by the first authors quoted, which already implied the existence

of events of two orders, those of the natural world and those of the supernatural world. But the definitions of Solovyov, James, et al. indicated further the possibility of supplying two explanations of the supernatural event and, consequently, the fact that *someone* must choose between them. It was therefore more suggestive, richer; and the one we ourselves have given is derived from it. It further emphasizes the differential character of the fantastic (as a dividing line between the uncanny and the marvelous), instead of making it a substance (as Castex, Caillois, et al. do). As a rule, moreover, a genre is always defined in relation to the genres adjacent to it.

But the definition still lacks distinctness, and it is here that we must go further than our predecessors. As has already been noted, they do not specify whether it is the reader or the character who hesitates, nor do they elucidate the nuances of the hesitation. *Le Diable Amoureux* offers insufficient substance for a more extended analysis: here the hesitation occupies us only a moment. We shall therefore turn to another book, written some twenty years later, which permits us to raise more questions; a book which magisterially inaugurates the period of the fantastic narrative, Jan Potocki's *Saragossa Manuscript*.

A series of events is initially related, none of which in isolation contradicts the laws of nature as experience has taught us to recognize them; but their accumulation raises a problem. Alfonso van Worden, the work's hero and narrator, is crossing the mountains of the Sierra Morena. Suddenly his *zagal* (valet) Moschite vanishes; some hours later, the other valet, Lopez, vanishes as well. The local inhabitants assert that the region is haunted by ghosts, those of two bandits who had recently been hanged. Alfonso reaches an abandoned inn and prepares to go to sleep, but at the first stroke of midnight, "a beautiful negress, half naked and bearing a torch in each hand," enters his room and invites him to follow her. She leads him to an underground chamber where he is

received by two young sisters, both lovely and very scantily clad. They offer him food and drink. Alfonso experiences strange sensations, and a doubt is born in his mind: "I no longer knew whether they were women or insidious succubae." They then tell him their story, revealing themselves to be his own cousins. But as the first cock crows, the narrative is broken off; and Alfonso recalls that "as everyone knows, ghosts have power only from midnight till cockcrow."

All this, of course, does not transcend the laws of nature as we know them. At most, one might say that they are strange events, unexpected coincidences. The next development is the decisive one: an event occurs which reason can no longer explain. Alfonso goes to bed, the two sisters join him (or perhaps he only dreams they do), but one thing is certain: when he awakes, he is no longer in a bed, he is no longer in an underground chamber. "I saw the sky. I saw that I was in the open air. . . . I was lying under the gallows of Los Hermanos, and beside me — the bodies of Zoto's two brothers!" Here then is a first supernatural event: two lovely girls have turned into two rotting corpses.

Alfonso is not yet convinced of the existence of supernatural forces: a conviction which would have suppressed all hesitation (and put an end to the fantastic). He looks for a place to spend the night, and comes upon a hermit's cottage; here he encounters a man possessed by the devil, Pascheco, who tells his story, a story which strangely resembles Alfonso's own: Pascheco had slept in the same inn; he had entered an underground chamber and spent the night in a bed with two sisters; the next morning *he* had wakened under the gallows, between two corpses. This similarity puts Alfonso on his guard. Hence he later explains to the hermit that he does not believe in ghosts, and he gives a "natural" explanation of Pascheco's misfortunes. He similarly interprets his own adventures:

I did not doubt that my cousins were women of flesh and blood.
I was convinced of this by some emotion more powerful than

all I had been told as to the power of the demons. As to the trick that had been played upon me of placing me under the gallows — I was greatly incensed by it.

So be it — until new developments rekindle Alfonso's doubts. He again encounters his cousins in a cave, and one night, they come to his bed. They are about to remove their chastity belts, but first Alfonso himself must remove the Christian relic he wears around his neck; in place of this object, one of the sisters bestows a braid of her hair. No sooner are the first transports of love over, than the stroke of midnight is heard.... Someone enters the cave, drives out the sisters and threatens Alfonso with death, obliging him to drink a cup of some unknown liquid. The next morning Alfonso wakens, of course, under the gallows, beside the corpses; around his neck there is no longer the braid of hair, but in its place a noose. Returning to the inn where he had spent the first night, he suddenly discovers, between the floorboards, the relic taken from him in the cave. "I no longer knew what I was doing.... I began to imagine that I had never really left this wretched inn, and that the hermit, the inquisitor [see below] and Zoto's brothers were so many phantoms produced by magic spells." As though to weigh the scale more heavily, he soon meets Pascheco, whom he had glimpsed during his last nocturnal adventure, and who gives him an entirely different version of the incident:

These two young persons, after bestowing certain caresses upon him, removed from around his neck a relic which had encircled it, and from that moment, they lost their beauty in my eyes, and I recognized in them the two hanged men of the valley of Los Hermanos. But the young horseman, still taking them for charming persons, lavished the tenderest endearments upon them. Then one of the hanged men removed the noose from around his neck and placed it around that of the horseman, who thanked him for it by renewed caresses. Finally they closed their curtain, and I do no know what they did then, but I believe it was some hideous sin.

What are we to believe? Alfonso knows for sure that he has spent the night with two lascivious women — but what to make of the awakening under the gallows, what of the rope around his neck, what of the relic in the inn, and what of Pascheco's narrative? Uncertainty and hesitation are at their height, reinforced by the fact that other characters suggest to Alfonso a supernatural explanation of the events. For example, the inquisitor, who will arrest Alfonso and threaten him with torture, asks him: "Do you know two Tunisian princesses? Or, rather, two infamous witches, execrable vampires and demons incarnate?" And later on Rebecca, Alfonso's hostess, will tell him: "We know that they are two female demons whose names are Emina and Zibeddé."

Alone for several days, Alfonso once again finds the forces of reason returning. He seeks a "realistic" explanation for these incidents.

I then recalled the words which had escaped Don Emmanuel de Sa, governor of this city, which made me think that he was not altogether alien to the mysterious existence of the Gomélez creatures. It was the governor who had given me my two valets, Lopez and Moschite. I took it into my head that it was upon his orders that they had left me at the disastrous valley of Los Hermanos. My cousins, and Rebecca herself, had often led me to believe that I was being tested. Perhaps at the inn I had been given some drug to put me to sleep, and subsequently nothing was easier than to transport me, in my unconscious state, beneath the fatal gallows. Pascheco might have lost an eye through some other accident than his amorous relations with the two hanged men, and his hideous story might well have been an invention. The hermit who had constantly sought to pluck out the heart of my mystery was doubtless an agent of the Gomélez, who wished to test my discretion. Finally Rebecca, her brother, Zoto, and the leader of the Gypsies — perhaps all these people were in league to put my courage to the test.

The uncertainty is not thereby settled: minor incidents will once again incline Alfonso toward a supernatural solution.

Outside his window, he sees two women who appear to be the famous sisters; but when he approaches them, he finds their faces utterly unknown to him. He then reads a satanic tale which so resembles his own story that he admits: "I nearly reached the point of believing that fiends, in order to deceive me, had animated the bodies of the hanged men."

"I nearly reached the point of believing": that is the formula which sums up the spirit of the fantastic. Either total faith or total incredulity would lead us beyond the fantastic: it is hesitation which sustains its life.

Who hesitates in this story? As we see at once, it is Alfonso — in other words, the hero, the central character. It is Alfonso who, throughout the plot, must choose between two interpretations. But if the reader were informed of the "truth," if he knew which solution to choose, the situation would be quite different. The fantastic therefore implies an integration of the reader into the world of the characters; that world is defined by the reader's own ambiguous perception of the events narrated. It must be noted that we have in mind no actual reader, but the role of the reader implicit in the text (just as the narrator's function is implicit in the text). The perception of this implicit reader is given in the text, with the same precision as the movements of the characters.

The reader's hesitation is therefore the first condition of the fantastic. But is it necessary that the reader identify with a particular character, as in *Le Diable Amoureux* and in *The Saragossa Manuscript*? In other words, is it necessary that the hesitation be *represented* within the work? Most works which fulfill the first condition also satisfy the second. Nonetheless there exist exceptions: for example in Villiers de l'Isle-Adam's "Véra." Here the reader may question the resurrection of the count's wife, a phenomenon which contradicts the laws of nature but seems to be confirmed by a series of secondary indications. Yet none of the characters

shares this hesitation: neither Count d'Athol, who firmly believes in Véra's second life, nor the old servant Raymond. The reader therefore does not identify with any character, and his hesitation is not represented within the text. We may say that this rule of identification involves an optional condition of the fantastic: the fantastic *may* exist without satisfying this condition; but it will be found that most works of fantastic literature are subject to it.

When the reader emerges from the world of the characters and returns to his own *praxis* (that of a reader) a new danger threatens the fantastic: a danger located on the level of the interpretation of the text. There exist narratives which contain supernatural elements without the reader's ever questioning their nature, for he realizes that he is not to take them literally. If animals speak in a fable, doubt does not trouble the reader's mind: he knows that the words of the text are to be taken in another sense, which we call *allegorical*. The converse situation applies to *poetry*. The poetic text might often be judged fantastic, provided we required poetry to be representative. But the question does not come up. If it is said, for instance, that the "poetic I" soars into space, this is no more than a verbal sequence, to be taken as such, without there being any attempt to go beyond the words to images.

The fantastic implies, then, not only the existence of an uncanny event, which provokes a hesitation in the reader and the hero; but also a kind of reading, which we may for the moment define negatively: it must be neither "poetic" nor "allegorical." If we return now to *The Saragossa Manuscript*, we see that this requirement is fulfilled in both respects. On the one hand, nothing permits us to give, immediately, an allegorical interpretation to the supernatural events described; on the other hand, these events are actually given as such, we are to represent them to ourselves, and not to consider the words which designate them as merely a combination of linguistic units. A remark by Roger Caillois gives us a clue as to this property of the fantastic text:

This kind of image is located at the very heart of the fantastic, halfway between what I have chosen to call infinite images and limited images. . . . The former seek incoherence as a principle and reject any signification; the latter translate specific texts into symbols for which an appropriate lexicon permits a term-by-term reconversion into corresponding utterances.

We are now in a position to focus and complete our definition of the fantastic. The fantastic requires the fulfillment of three conditions. First, the text must oblige the reader to consider the world of the characters as a world of living persons and to hesitate between a natural and a supernatural explanation of the events described. Second, this hesitation may also be experienced by a character; thus the reader's role is so to speak entrusted to a character, and at the same time the hesitation is represented, it becomes one of the themes of the work — in the case of naive reading, the actual reader identifies himself with the character. Third, the reader must adopt a certain attitude with regard to the text: he will reject allegorical as well as "poetic" interpretations. These three requirements do not have an equal value. The first and the third actually constitute the genre; the second may not be fulfilled. Nonetheless, most examples satisfy all three conditions.

How are these three characteristics to take their place within the model of the work as we have articulated it in the preceding chapter? The first condition refers us to the *verbal* aspect of the text, more precisely, to what are called "visions": the fantastic is a particular case of the more general category of the "ambiguous vision." The second condition is more complex: it is linked on the one hand to the *syntactical* aspect, insofar as it implies the existence of formal units which correspond to the characters' estimation of events in the narrative; we might call these units "reactions," as opposed to the "actions" which habitually constitute the argument of the narrative; on the other hand, this second condition refers to the *semantic* aspect, since we are concerned with a rep-

resented theme, that of perception and of its notation. Lastly, the third condition has a more general nature and transcends the division into aspects: here we are concerned with a choice between several modes (and levels) of reading.

We may now regard our definition as sufficiently explicit. In order to justify it fully, let us compare it once again to several other definitions, this time definitions which will permit us to see not how ours resembles them but how it is distinguished from them. From a systematic point of view, we may start in several directions from the word "fantastic."

why?

First of all let us take the meaning which, though rarely articulated, comes to mind straight off (that of the dictionary): in the fantastic texts, the author describes events which are not likely to occur in everyday life. We might indeed characterize such events as *supernatural*, but the supernatural, though a literary category, of course, is not relevant here. We cannot conceive a genre which would regroup all works in which the supernatural intervenes and which would thereby have to accommodate Homer as well as Shakespeare, Cervantes as well as Goethe. The supernatural does not characterize works closely enough, its extension is much too great.

Another endeavor to situate the fantastic, one much more widespread among theoreticians, consists in identifying it with certain reactions of the reader: not the reader implicit in the text, but the actual person holding the book in his hand. Representative of this tendency is H.P. Lovecraft, himself the author of fantastic tales as well as of a theoretical work devoted to the supernatural in literature. For Lovecraft, the criterion of the fantastic is not situated within the work but in the reader's individual experience — and this experience must be fear.

> Atmosphere is most important, for the ultimate criterion of authenticity [of the fantastic] is not plot structure but the creation of a specific impression.... Hence we must judge the fantastic tale not so much by the author's intentions and the mechanisms of the plot, but by the emotional intensity it provokes.... A tale is

fantastic if the reader experiences an emotion of profound fear
and terror, the presence of unsuspected worlds and powers.

This sentiment of fear or perplexity is often invoked by
theoreticians of the fantastic, even if they continue to regard
a possible double explanation as the necessary condition of
the genre. Thus Peter Penzoldt writes: "With the exception
of the fairy tale, all supernatural stories are stories of fear
which make us wonder if what is supposed to be mere imagina-
tion is not reality after all." Caillois, too, proposes as a "touch-
stone of the fantastic . . . the impression of irreducible strange-
ness."
 It is surprising to find such judgments offered by serious
critics. If we take their declarations literally — that the senti-
ment of fear must occur in the reader — we should have
to conclude that a work's genre depends on the *sang-froid*
of its reader. Nor does the determination of the sentiment
of fear in the *characters* offer a better opportunity to delimit
the genre. In the first place, fairy tales can be stories of fear,
as in the case of Perrault (contrary to Penzoldt's assertion).
Moreover, there are certain fantastic narratives from which
all terror is absent: texts as diverse as Hoffmann's "Princess
Brambilla" and Villiers de l'Isle-Adam's "Véra." Fear is
often linked to the fantastic, but it is not a necessary condition
of the genre.
 Strange as it seems, efforts have also been made to locate
the essence of the fantastic in the *author*. An example of
this is to be found in Caillois who, in any case, has no fear
of contradictions. Here is how Caillois revives the romantic
image of the inspired poet: "The fantastic must have something
of the involuntary about it, something submitted to — an inter-
rogation as troubled as it is troublesome, rising suddenly from
a darkness which its author was obliged to take just as it
came. . . ." Or further: "Once again, the fantastic which
does not proceed from a deliberate intention to disconcert
but which seems to develop despite the work's author, if not

unknown to him, turns out to be the most persuasive of all."
Arguments against this "intentional fallacy" are today too
familiar to be reformulated here.

Other attempts at definition deserve still less attention
since they could as well be applied to texts which are not
fantastic at all. Thus it is not possible to define the fantastic
in terms of opposition to the faithful reproduction of reality,
or in terms of opposition to naturalism. Nor in the terms
used by Marcel Schneider in *La Littérature Fantastique en
France*: "The fantastic explores inner space; it sides with
the imagination, the anxiety of existence, and the hope of
salvation."

The Saragossa Manuscript has furnished us an example
of hesitation between the real and (let us say) the *illusory*:
we wondered if what we saw was not a trick, or an error
of perception. In other words, we did not know what interpre-
tation to give to certain perceptible events. There exists
another variety of the fantastic in which the hesitation occurs
between the real and the *imaginary*. In the first case, we
were uncertain not that the events occurred, but that our under-
standing of them was correct. In the second case, we wonder
if what we believe we perceive is not in fact a product of
the imagination: "I have difficulty differentiating what I see
with the eyes of reality from what my imagination sees,"
says one of Achim von Arnim's characters. This "error"
may occur for several reasons which we shall examine below;
here is a characteristic example of it, in which the confused
perception is imputed to madness: E. T. A. Hoffmann's
"Princess Brambilla."

Strange and incomprehensible events occur in the life
of the poor actor Giglio Fava during the Carnival in Rome.
He believes that he has become a prince, has fallen in love
with a princess, and has had incredible adventures. Now,
most of those around him assure him that nothing of the kind
has taken place but that he, Giglio, has gone mad. This is
the claim of Signor Pasquale: "Signor Giglio, I know what

has happened to you. All Rome knows as well, you have been forced to leave the theatre because your mind is deranged...." Sometimes Giglio himself doubts his own reason: "He was even ready to think that Signor Pasquale and Maestro Bescapi had been right to believe him a little cracked." Thus Giglio (and the implicit reader) is kept in doubt, uncertain if what surrounds him is or is not the product of his imagination.

This simple and very common procedure may be contrasted with another which appears to be much rarer, and in which madness is utilized once again, but differently, in order to create the necessary ambiguity. Consider Nerval's *Aurélia*: this book, as we know, is the account of certain visions seen by a man during a period of madness. Although the narrative is given in the first person, the *I* apparently comprehends two distinct persons: a character who perceives unknown worlds (and lives in the past), and the narrator who transcribes the former's impressions (he lives in the present). At first glance, the fantastic does not exist here: neither for the former, who regards his visions not as due to madness but as a more lucid image of the world (he is thus in the realm of the marvelous); nor for the latter, who knows that the visions are the product of either madness or dreams, not of reality (from his viewpoint, the narrative is merely uncanny). But the text does not function in just this way, for Nerval recreates the ambiguity at another level, where we did not expect it; and *Aurélia* thus remains within the bounds of the true fantastic after all.

In the first place, the character has not entirely decided what interpretation to give to events. Sometimes he too believes in his own madness, but never to the point of certainty. "I understood, seeing myself among madmen, that hitherto everything had been only illusions. Yet the promises I once attributed to the goddess Isis seemed to turn into a series of ordeals I was destined to undergo." At the same time, the narrator is not sure that everything the character has

experienced results from illusion. He even insists on the truth of certain of the phenomena described: "I inquired in other quarters, no one had heard anything. And yet I am still certain that the cry was real, and the earthly air had echoed to it...."

Ambiguity also results from the use of two stylistic devices which suffuse the entire text: imperfect tense and modalization. Nerval habitually employs them together. The latter consists, let us note, in using certain introductory locutions which, without changing the meaning of the sentence, modify the relation between the speaker and his utterance. For example, the two sentences "It is raining outside" and "Perhaps it is raining outside" refer to the same fact; but the second also indicates the speaker's uncertainty as to the truth of the sentence he utters. The imperfect has a similar effect. If I say "I used to love Aurélia [*J'aimais Aurélia*]," I do not specify whether or not I still love her now; the continuity is *possible*, but as a general rule *unlikely*.

Now the entire text of *Aurélia* is impregnated by these two devices. Whole pages might be quoted from it in support of this assertion. Here are several examples taken at random:

> *It seemed to me that* I was returning to a familiar house. . . .
> An old servant whom I called Marguerite and whom I *seemed
> to have known* since childhood told me.... *I believed* I was
> falling into an abyss which split the globe. I *felt* painlessly swept
> away by a flood of molten metal.... *I had the sense* that these
> currents were constituted of living souls, in a molecular state.
> ... *It became clear to me* that the ancestors were taking the
> form of certain animals in order to visit us on earth. . . [my italics].

Without these locutions, we should be plunged into the world of the marvelous, with no reference to everyday reality. By means of them, we are kept in both worlds at once. The imperfect tense (less apparent in the English translation) introduces a further distance between the character and the

narrator, so that we are kept from knowing the latter's position.

By a series of interpolated clauses, the narrator keeps his distance from others — from the "normal man," or, more exactly, from the normal use of certain words (for in a sense, *language* is the main theme of *Aurélia*). "Recovering what men call reason," he writes somewhere. And again: "But it appears that this was an illusion of sight." Or once more: "My apparently meaningless actions were subject to what is called illusion, according to human reason." An admirable sentence: the actions are "meaningless" (reference to the natural) but only "apparently" so (reference to the super-natural); they are subject to illusion (reference to the natural), or rather not to "what is called illusion" (reference to the supernatural). The imperfect tense, moreover, signifies that it is not the present narrator who thinks this way, but the character at that particular time. And again this phrase, which epitomizes the pervasive ambiguity of *Aurélia*: "A series of mad visions perhaps." The narrator here keeps his distance from the "normal man" and draws closer to the character; and the certainty that he is dealing with madness thus gives way to doubt.

Indeed, the narrator will go further: he will openly adopt the character's view that madness and dreaming are only a higher form of reason. Here is what the character had said: "The testimony of those who had seen me thus caused me a kind of irritation when I realized that they attributed to mental aberration the movements or words coinciding with the various phases of what for me constituted a series of logical events" (this corresponds to Poe's remark: "Science has not yet told us whether madness may not be the sublime form of intelligence"). And again: "Having come to this notion of dreams affording man a communication with the world of spirits, I hoped. . . ." But here is how the narrator speaks:

I shall try . . . to transcribe the impressions of a long disease which has occurred entirely within the mysteries of my own mind

— and I don't know why I use this word disease, for I myself have never felt in better health. Sometimes I believed my strength and activity to have doubled; imagination afforded me infinite delights.

Or again: "Whatever the case, I believe that the human imagination has invented nothing which is not true, in this world or in others, and I could not doubt what I had *seen* so distinctly." (Again perhaps an echo of Poe's "The mind of man can *imagine* nothing which has not really existed.")

In these two passages, Nerval's narrator seems to declare that what he has seen during his so-called madness is only a part of reality — that he has therefore never been ill. But if each of the passages begins in the present, the final proposition once again occurs in the imperfect tense and it thus reintroduces ambiguity into the reader's perception. The converse occurs in the last sentences of *Aurélia*: "I was able to judge more soundly the world of illusions in which I had lived for a time. Still, I feel happy in the convictions I have acquired. . . ." The first proposition seems to refer whatever precedes it to the world of madness; but then, why this happiness in the convictions acquired?

Aurélia constitutes, then, an original — and perfect — example of the ambiguity of the fantastic. This ambiguity turns on madness, certainly; but whereas in Hoffmann's "Princess Brambilla" we questioned whether or not the character was mad, in *Aurélia* we know in advance that the behavior of Nerval's protagonist is considered madness. What we are concerned to know (and it is on this point that the hesitation turns) is whether or not madness is actually a higher reason. The hesitation previously concerned perception; now it concerns language. With Hoffmann, we hesitate as to the name for certain events; with Nerval, the hesitation shifts inside the name: to its meaning.

3

the uncanny and the marvelous

The fantastic, we have seen, lasts only as long as a certain hesitation: a hesitation common to reader and character, who must decide whether or not what they perceive derives from "reality" as it exists in the common opinion. At the story's end, the reader makes a decision even if the character does not; he opts for one solution or the other, and thereby emerges from the fantastic. If he decides that the laws of reality remain intact and permit an explanation of the phenomena described, we say that the work belongs to another genre: the uncanny. If, on the contrary, he decides that new laws of nature must be entertained to account for the phenomena, we enter the genre of the marvelous.

The fantastic therefore leads a life full of dangers, and may evaporate at any moment. It seems to be located on the frontier of two genres, the marvelous and the uncanny, rather than to be an autonomous genre. One of the great periods of supernatural literature, that of the Gothic novel, seems to confirm this observation. Indeed, we generally distinguish, within the literary Gothic, two tendencies: that of the supernatural explained (the "uncanny"), as it appears in the novels of Clara Reeves and Ann Radcliffe; and that

of the supernatural accepted (the "marvelous"), which is characteristic of the works of Horace Walpole, M. G. Lewis, and Maturin. Here we find not the fantastic in the strict sense, only genres adjacent to it. More precisely, the effect of the fantastic is certainly produced, but during only a portion of our reading: in Ann Radcliffe, up to the moment when we are sure that everything which has happened is susceptible of a rational explanation; in M.G. Lewis, up to the moment when we are sure that the supernatural events will receive *no* explanation. Once we have finished reading, we understand — in both cases — that what we call the fantastic has not existed.

We may ask how valid a definition of genre may be if it permits a work to "change genre" by a simple sentence like: "At this moment, he awakened and saw the walls of his room. . . ." But there is no reason not to think of the fantastic as an evanescent genre. Such a category, moreover, has nothing exceptional about it. The classic definition of the *present*, for example, describes it as a pure limit between the past and the future. The comparison is not gratuitous: the marvelous corresponds to an unknown phenomenon, never seen as yet, still to come — hence to a future; in the uncanny, on the other hand, we refer the inexplicable to known facts, to a previous experience, and thereby to the past. As for the fantastic itself, the hesitation which characterizes it cannot be situated, by and large, except in the present.

Here we also are faced with the problem of the work's unity. We take this unity as self-evident, and we assert that a sacrilege has been committed when cuts are made. But matters are probably more complicated; let us not forget that in school, where our first, and decisive, experience of literature occurred, we read only "selected passages" or "extracts" from most works. A certain fetishism of the book survives in our own day and age: the literary work is transformed both into a precious and motionless object and into a symbol of plenitude, and the act of cutting it becomes an equivalent

of castration. How much freer was the attitude of a Khleb-
nikov, who composed his poems out of fragments of preceding
poems and who urged his editors and even his printers to
revise his text! Only an identification of the book with its
author explains our horror of cuts.

If we do decide to proceed by examining certain parts
of the work in isolation, we discover that by temporarily omit-
ting the end of the narrative we are able to include a much
larger number of texts within the genre of the fantastic. The
modern (French or English) editions of *The Saragossa
Manuscript* precisely confirm this: without its end, which
resolves the hesitation, the book clearly belongs to the fantas-
tic. Charles Nodier, one of the pioneers of the fantastic in
France, thoroughly understood this, and deals with it in one
of his tales, "Inès de las Sierras." This text consists of two
apparently equal parts, and the end of the first part leaves
us in utter perplexity: we are at a loss to explain the strange
phenomena which occur; on the other hand, we are not as
ready to admit the supernatural as we are to embrace the
natural. The narrator hesitates between two procedures: to
break off his narrative (and remain in the fantastic) or to con-
tinue (and abandon it). His own preference, he declares to
his hearers, is to stop, with the following justification: "Any
other outcome would be destructive to my story, for it would
change its nature."

Yet it would be wrong to claim that the fantastic can
exist only in a part of the work, for here are certain texts
which sustain their ambiguity to the very end, i.e., even beyond
the narrative itself. The book closed, the ambiguity persists.
A remarkable example is supplied by Henry James' tale "The
Turn of the Screw," which does not permit us to determine
finally whether ghosts haunt the old estate, or whether we
are confronted by the hallucinations of a hysterical governess
victimized by the disturbing atmosphere which surrounds her.
In French literature, Mérimée's tale "La Vénus d'Ille" affords
a perfect example of this ambiguity. A statue seems to come

alive and to kill the bridegroom; but we remain at the point of "seems," and never reach certainty.

Whatever the case, we cannot exclude from a scrutiny of the fantastic either the marvelous or the uncanny, genres which it overlaps. But we must not, on the other hand, forget Louis Vax's remark that "an ideal art of the fantastic must keep to indecision."

Let us take a closer look, then, at these two neighbors. We find that in each case, a transitory sub-genre appears: between the fantastic and the uncanny on the one hand, between the fantastic and the marvelous on the other. These sub-genres include works that sustain the hesitation characteristic of the true fantastic for a long period, but that ultimately end in the marvelous or in the uncanny. We may represent these sub-divisions with the help of the following diagram:

| uncanny | *fantastic-uncanny* | *fantastic-marvelous* | *marvelous* |

The fantastic in its pure state is represented here by the median line separating the fantastic-uncanny from the fantastic-marvelous. This line corresponds perfectly to the nature of the fantastic, a frontier between two adjacent realms.

Let us begin with the fantastic-uncanny. In this sub-genre events that seem supernatural throughout a story receive a rational explanation at its end. If these events have long led the character and the reader alike to believe in an intervention of the supernatural, it is because they have an unaccustomed character. Criticism has described, and often condemned, this type under the label of "the supernatural explained."

Let us take as an example of the fantastic-uncanny the same *Saragossa Manuscript*. All of the "miracles" are explained rationally at the end of the narrative. Alfonso meets in a cave the hermit who had sheltered him at the beginning,

and who is the grand sheik of the Gomélez himself. This
man reveals the machinery of all the foregoing events:

> Don Emmanuel de Sa, the Governor of Cadiz, is one of the
> initiates. He had sent you Lopez and Moschite, who abandoned
> you at the spring of Alcornoques. . . .By means of a sleeping
> potion you were made to waken the next day under the gallows
> of the Zoto brothers. Whence you came to my hermitage, where
> you encountered the dreadful Pascheco, who is in fact a Basque
> dancer. . . .The following day, you were subjected to a far crueler
> ordeal: the false inquisition which threatened you with horrible
> tortures but did not succeed in shaking your courage.

Doubt had been sustained up to this point, as we know,
between two poles: the existence of the supernatural and a
series of rational explanations. Let us now enumerate the
types of explanation that erode the case for the supernatural:
first, accident or coincidence — for in the supernatural world,
instead of chance there prevails what we might call "pan-
determinism" (an explanation in terms of chance is what works
against the supernatural in "Inès de las Sierras"); next, dreams
(a solution proposed in *Le Diable Amoureux*); then the influ-
ence of drugs (Alfonso's dreams during the first night); tricks
and prearranged apparitions (an essential solution in *The
Saragossa Manuscript*); illusion of the senses (we shall find
examples of this in Théophile Gautier's "La Morte Amour-
euse" and John Dickson Carr's *The Burning Court*); and
lastly madness, as in Hoffmann's "Princess Brambilla."
There are obviously two groups of "excuses" here which
correspond to the oppositions real/imaginary and real/illusory.
In the first group, there has been no supernatural occurrence,
for nothing at all has actually occurred: what we imagined we
saw was only the fruit of a deranged imagination (dream,
madness, the influence of drugs). In the second group, the
events indeed occurred, but they may be explained rationally
(as coincidences, tricks, illusions).

We recall that in the definitions of the fantastic cited above, the rational solution was decided as "completely stripped of internal probability" (Solovyov) or as a loophole "small enough to be unusable" (M.R. James). Indeed, the realistic solutions given in *The Saragossa Manuscript* or "Inès de las Sierras" are altogether improbable; supernatural solutions would have been, on the contrary, quite probable. The coincidences are too artificial in Nodier's tale. As for *The Saragossa Manuscript,* its author does not even try to concoct a credible ending: the story of the treasure, of the hollow mountain, of the empire of the Gomélez is more incredible than that of the women transformed into corpses! The probable is therefore not necessarily opposed to the fantastic: the former is a category that deals with internal coherence, with submission to the genre; the *fantastic* refers to an ambiguous perception shared by the reader and one of the characters. Within the genre of the fantastic, it is *probable* that "fantastic" reactions will occur.

In addition to such cases as these, where we find ourselves in the uncanny rather in spite of ourselves — in order to explain the fantastic — there also exists the uncanny in the pure state. In works that belong to this genre, events are related which may be readily accounted for by the laws of reason, but which are, in one way or another, incredible, extraordinary, shocking, singular, disturbing or unexpected, and which thereby provoke in the character and in the reader a reaction similar to that which works of the fantastic have made familiar. The definition is, as we see, broad and vague, but so is the genre which it describes: the uncanny is not a clearly delimited genre, unlike the fantastic. More precisely, it is limited on just one side, that of the fantastic; on the other, it dissolves into the general field of literature (Dostoievsky's novels, for example, may be included in the category of the uncanny). According to Freud, the sense of the uncanny

is linked to the appearance of an image which originates in the childhood of the individual or the race (a hypothesis still to be verified; there is not an entire coincidence between Freud's use of the term and our own). The literature of horror in its pure state belongs to the uncanny — many examples from the stories of Ambrose Bierce could serve as examples here.

The uncanny realizes, as we see, only one of the conditions of the fantastic: the description of certain reactions, especially of fear. It is uniquely linked to the sentiments of the characters and not to a material event defying reason. (The marvelous, by way of contrast, may be characterized by the mere presence of supernatural events, without implicating the reaction they provoke in the characters.)

Poe's tale "The Fall of the House of Usher" is an instance of the uncanny bordering on the fantastic. The narrator of this tale arrives at the house one evening summoned by his friend Roderick Usher, who asks him to stay for a time. Usher is a hypersensitive, nervous creature who adores his sister, now seriously ill. When she dies some days later, the two friends, instead of burying her, leave her body in one of the vaults under the house. Several days pass. On a stormy night the two men are sitting in a room together, the narrator reading aloud an ancient tale of chivalry. The sounds that are described in the chronicle seem to correspond to the noises they hear in the house itself. At the end, Roderick Usher stands up and says, in a scarcely audible voice: "We have put her living in the tomb!" And, indeed, the door opens, the sister is seen standing on the threshold. Brother and sister rush into each other's arms, and fall dead. The narrator flees the house just in time to see it crumble into the environing tarn.

Here the uncanny has two sources. The first is constituted by two coincidences (there are as many of these as in a work of the *supernatural explained*). Although the resurrection of Usher's sister and the fall of the house after the death of

its inhabitants may appear supernatural, Poe has not failed to supply quite rational explanations for both events. Of the house, he writes: "Perhaps the eye of a scrutinizing observer might have discovered a barely perceptible fissure, which, extending from the roof of the building in front, made its way down the wall in a zig-zag direction, until it became lost in the sullen waters of the tarn." And of Lady Madeline: "Frequent although transient affections of a partially catalepti-cal character were the unusual diagnosis." Thus the super-natural explanation is merely suggested, and one need not accept it.

The other series of elements that provoke the sense of the uncanny is not linked to the fantastic but to what we might call "an experience of limits," which characterizes the whole of Poe's *oeuvre*. Indeed, Baudelaire wrote of Poe: "No man has more magically described the *exceptions* of human life and of nature." Likewise Dostoievsky: "He almost always chooses the most exceptional reality, puts his character in the most exceptional situation, on the external or psychological level. . . ." (Poe, moreover, wrote a tale on this theme, a "meta-uncanny" tale entitled "The Angel of the Odd.") In "The Fall of the House of Usher," it is the extremely morbid condition of the brother and sister which disturbs the reader. In other tales, scenes of cruelty, delight in evil, and murder will provoke the same effect. The sentiment of the uncanny originates, then, in certain themes linked to more or less ancient taboos. If we grant that primal experience is constituted by transgression, we can accept Freud's theory as to the origin of the uncanny.

Thus the fantastic is ultimately excluded from "The Fall of the House of Usher." As a rule, we do not find the fantastic in Poe's works, in the strict sense, with the exception perhaps of "The Black Cat." His tales almost all derive their effect from the uncanny, and several from the marvelous. Yet Poe remains very close to the authors of the fantastic both in his themes and in the techniques that he applies.

We also know that Poe originated the detective story or murder mystery, and this relationship is not a matter of chance. It has often been remarked, moreover, that for the reading public, detective stories have in our time replaced ghost stories. Let us consider the nature of this relationship. The murder mystery, in which we try to discover the identity of the criminal, is constructed in the following manner: on the one hand there are several easy solutions, initially tempting but turning out, one after another, to be false; on the other, there is an entirely improbable solution disclosed only at the end and turning out to be the only right one. Here we see what brings the detective story close to the fantastic tale. Recalling Solovyov's and James's definitions, we note that the fantastic narrative, too, involves two solutions, one probable and supernatural, the other improbable and rational. It suffices, therefore, that in the detective story this second solution be so inaccessible as to "defy reason" for us to accept the existence of the supernatural rather than to rest with the absence of any explanation at all. A classical example of this situation is Agatha Christie's *Ten Little Indians*. Ten characters are isolated on an island; they are told (by a recording) that they will all die, punished for a crime which the law cannot punish. The nature of each death, moreover, is described in the counting-rhyme "Ten Little Indians." The doomed characters — and the reader along with them — vainly try to discover who is carrying out the successive executions. They are alone on the island and dying one after another, each in a fashion announced by the rhyme; down to the last one, who — and it is this that arouses an aura of the supernatural — does not commit suicide but is killed in his turn. No rational explanation seems possible, we must admit the existence of invisible beings or spirits. Obviously this hypothesis is not really necessary: the rational explanation will be given. The murder mystery approaches the fantastic, but it is also the contrary of the fantastic: in fantastic texts, we tend to prefer the supernatural explanation; the detective

story, once it is over, leaves no doubt as to the absence of supernatural events. This relationship, moreover, is valid only for a certain type of detective story (the "sealed room") and a certain type of uncanny narrative (the "supernatural explained"). Further, the emphasis differs in the two genres: in the detective story, the emphasis is placed on the solution to the mystery; in the texts linked to the uncanny (as in the fantastic narrative), the emphasis is on the reactions which this mystery provokes. This structural proximity nonetheless produces a resemblance which we must take into account.

An author who deserves a more extended scrutiny when we deal with the relation between detective stories and fantastic tales is John Dickson Carr. Among his books there is one in particular which raises the problem in an exemplary fashion, *The Burning Court.* As in *Ten Little Indians*, we are confronted with an apparently insoluble problem: four men open a crypt in which a corpse had been placed a few days before; the crypt is empty, but it is not possible that anyone could have opened it in the meantime. Throughout the story, moreover, ghosts and supernatural phenomena are evoked. There is a witness to the crime that had taken place, and this witness asserts he has seen the murderess leave the victim's room, passing through the wall at a place where a door existed two hundred years earlier. Furthermore, one of the persons implicated in the case, a young woman, believes herself to be a witch, or more precisely, a poisoner (the murder was the result of poison) who belongs to a particular type of human beings, *the non-dead*: "Briefly, the non-dead are those persons — commonly women — who have been condemned to death for the crime of poisoning, and whose bodies have been burnt at the stake, whether alive or dead," we learn later on. While leafing through a manuscript he has received from the publishing house that he works for, Stevens, the young woman's husband, happens on a photograph whose caption reads: *Marie d'Aubray: Guillotined for Murder, 1861.*

The text continues: "He was looking at a photograph of his own wife." How could this young woman, some seventy years later, be the same person as a famous nineteenth-century poisoner, guillotined into the bargain? Quite simply, according to Stevens' wife, who is ready to assume responsibility for the present murder. A series of further coincidences seems to confirm the presence of the supernatural. Finally, a detective arrives, and everything begins to be explained. The woman who had been seen passing through the wall was an optical illusion caused by a mirror. The corpse had not vanished after all, but was cunningly concealed. Young Marie Stevens had nothing in common with a long-dead poisoner, though an effort had been made to make her believe that she had. The entire supernatural atmosphere had been created by the murderer in order to confuse the case, to avert suspicion. The actual guilty parties are discovered, even if they are not successfully punished.

Then follows an epilogue, as a result of which *The Burning Court* emerges from the class of detective stories that simply evoke the supernatural, to join the ranks of the fantastic. We see Marie once again, in her house, thinking over the case; and the fantastic re-emerges. Marie asserts once again (to the reader) that she is indeed the poisoner, that the detective was in fact her friend (which is not untrue), and that he has provided the entire rational explanation in order to save her ("It was clever of him to pluck a physical explanation, a thing of sizes and dimensions and stone walls").

The world of the non-dead reclaims its rights, and the fantastic with it: we are thrown back on our hesitation as to which solution to choose. But it must be noted, finally, that we are less concerned here with a resemblance between two genres than with their synthesis.

If we move to the *other* side of that median line which we have called the fantastic, we find ourselves in the fantastic-

marvelous, the class of narratives that are presented as fantastic and that end with an acceptance of the supernatural. These are the narratives closest to the pure fantastic, for the latter, by the very fact that it remains unexplained, unrationalized, suggests the existence of the supernatural. The frontier between the two will therefore be uncertain; nonetheless, the presence or absence of certain details will always allow us to decide.

Gautier's "La Morte Amoureuse" can serve as an example. This is the story of a monk (Romuald) who on the day of his ordination falls in love with the courtesan Clarimonde. After several fleeting encounters, Romuald attends Clarimonde's deathbed — whereupon she begins to appear in his dreams, dreams that have a strange property: instead of conforming to impressions of each passing day, they constitute a continuous narrative. In his dreams, Romuald no longer leads the austere life of a monk, but lives in Venice in continuous revelry. And at the same time he realizes that Clarimonde has been keeping herself alive by means of blood she sucks from him during the night. . . .

Up to this point, all the events are susceptible of rational explanations. The explanations are largely furnished by the dreams themselves ("May God grant that it is a dream!" Romuald exclaims, in this resembling Alvaro in *Le Diable Amoureux*). Illusions of the senses furnish another plausible explanation. Thus: "One evening, strolling along the box-lined paths of my little garden, *I seemed to see* through the hedgerow a woman's shape. . ."; "For a moment *I thought* I saw her foot move. . ."; "*I do not know if this was an illusion or a reflection of the lamp, but it seemed* that the blood began to circulate once more beneath that lustreless pallor," etc. (italics mine). Finally, a series of events can be considered as simply uncanny and due to chance. But Romuald himself is ready to regard the matter as a diabolic intervention:

The strangeness of the episode. Clarimonde's supernatural [!]

beauty, the phosphorescent lustre of her eyes, the burning touch of her hand, the confusion into which she had thrown me, the sudden change that had occurred in me — all of this clearly proved the presence of the Devil; and that silken hand was perhaps nothing but the glove in which he had clad his talons.

It might be the Devil, indeed, but it might also be chance and no more than that. We remain, then, up to this point in the fantastic in its pure state. At this moment there occurs an event which causes the narrative to swerve. Another monk, Serapion, learns (we do not know how) of Romuald's adventure. He leads the latter to the graveyard in which Clarimonde lies buried, unearths the coffin, opens it, and Clarimonde appears, looking just as she did on the day of her death, a drop of blood on her lips. . . . Seized by pious rage, Abbé Serapion flings holy water on the corpse. "The wretched Clarimonde had no sooner been touched by the holy dew than her lovely body turned to dust; nothing was left but a shapeless mass of ashes and half-consumed bones." This entire scene, and in particular the metamorphosis of the corpse, cannot be explained by the laws of nature as they are generally acknowledged. We are here in the realm of the fantastic-marvelous.

A similar example is to be found in Villiers de l'Isle-Adam's "Véra." Here again, throughout the tale, we may hesitate between believing in life-after-death or thinking that the count who so believes is mad. But at the end, the count discovers the key to Véra's tomb in his own room, though he himself had flung it into the grave; it must therefore be Véra, his dead wife, who has brought it to him.

There exists, finally, a form of the marvelous in the pure state which — just as in the case of the uncanny in the pure state — has no distinct frontiers (we have seen in the preceding chapter that extremely diverse works contain elements of the

marvelous). In the case of the marvelous, supernatural ele-
ments provoke no particular reaction either in the characters
or in the implicit reader. It is not an attitude toward the events
described which characterizes the marvelous, but the nature
of these events.

We note, in passing, how arbitrary the old distinction
was between form and content: the event, which traditionally
belonged to "content," here becomes a "formal" element.
The converse is also true: the stylistic (hence "formal") proce-
dure of modalization can have, as we have seen in connection
with *Aurélia*, a precise content.

We generally link the genre of the marvelous to that of
the fairy tale. But as a matter of fact, the fairy tale is only
one of the varieties of the marvelous, and the supernatural
events in fairy tales provoke no surprise: neither a hundred
years' sleep, nor a talking wolf, nor the magical gifts of the
fairies (to cite only a few elements in Perrault's tales). What
distinguishes the fairy tale is a certain kind of writing, not
the status of the supernatural. Hoffmann's tales illustrate this
difference perfectly: "The Nutcracker and the Mouse-King,"
"The Strange Child," and "The King's Bride" belong, by
stylistic properties, to the fairy tale. "The Choice of a Bride,"
while preserving the same status with regard to the super-
natural, is not a fairy tale at all. One would also have to
characterize the *Arabian Nights* as marvelous tales rather
than fairy tales (a subject which deserves a special study all
its own).

In order to delimit the marvelous in the pure state, it
is convenient to isolate it from several types of narrative in
which the supernatural is somewhat justified.

1. We may speak first of all of *hyperbolic marvelous*.
In it, phenomena are supernatural only by virtue of their
dimensions, which are superior to those that are familiar to
us. Thus in the *Arabian Nights* Sinbad the Sailor declares
he has seen "fish one hundred and even two hundred ells
long" or "serpents so great and so long that there was not

one which could not have swallowed an elephant.'' But perhaps this is no more than a simple manner of speaking (we shall study this question when we deal with the poetic or allegorical interpretation of the text); one might even say, adapting a proverb, that "fear has big eyes.'' In any case, this form of the supernatural does not do excessive violence to reason.

2. Quite close to this first type of the marvelous is the *exotic marvelous*. In this type, supernatural events are reported without being presented as such. The implicit reader is supposed to be ignorant of the regions where the events take place, and consequently he has no reason for calling them into question. Sinbad's second voyage furnishes some excellent examples, such as the *roc*, a bird so tremendous that it concealed the sun and "one of whose legs. . .was as great as a great tree-trunk.'' Of course, this bird does not exist for contemporary zoology, but Sinbad's hearers were far from any such certainty and, five centuries later, Galland himself writes: "Marco Polo, in his travels, and Father Martini, in his *History of China*, speak of this bird,'' etc. A little later, Sinbad similarly describes the rhinoceros, which however is well known to us:

> There is, on the same island, a rhinoceros, a creature smaller than the elephant and larger than the buffalo: it bears a single horn upon its snout, about one ell long; this horn is solid and severed through the center, from one end to the other. Upon it may be seen white lines which represent the face of a man. The rhinoceros attacks the elephant, pierces it with its horn through the belly, carries it off and bears it upon its head; but when the elephant's blood flows over its eyes and blinds it, the rhinoceros falls to the ground, and — what will amaze you [indeed], the roc comes and bears off both creatures in its talons, in order to feed its young upon their bodies.

This virtuoso passage shows, by its mixture of natural and supernatural elements, the special character of the *exotic*

marvelous. The mixture exists, of course, only for the modern reader; the narrator implicit in the tale situates everything on the same level (that of the "natural").

3. A third type of the marvelous might be called the *instrumental marvelous*. Here we find the gadgets, technological developments unrealized in the period described but, after all, quite possible. In the "Tale of Prince Ahmed" in the *Arabian Nights*, for instance, the marvelous instruments are, at the beginning: a flying carpet, an apple that cures diseases, and a "pipe" for seeing great distances; today, the helicopter, antibiotics, and binoculars, endowed with the same qualities, do not belong in any way to the marvelous. The same is true of the flying horse in the "Tale of the Magic Horse." Similarly in the case of the revolving stone in the "Tale of Ali Baba," we need only think of recent espionage films in which a safe opens only when its owner's voice utters certain words. We must distinguish these objects, products of human skill, from certain instruments that are often similar in appearance but whose origin is magical, and that serve to communicate with other worlds. Thus Aladdin's lamp and ring, or the horse in the " Third Calender's Tale," which belong to a different kind of marvelous.

4. The "instrumental marvelous" brings us very close to what in nineteenth-century France was called the *scientific marvelous*, which today we call *science fiction*. Here the supernatural is explained in a rational manner, but according to laws which contemporary science does not acknowledge. In the high period of fantastic narratives, stories involving magnetism are characteristic of the scientific marvelous: magnetism "scientifically" explains supernatural events, yet magnetism itself belongs to the supernatural. Examples are Hoffmann's "Spectre Bridegroom" or "The Magnetizer," and Poe's "The Facts in the Case of M. Valdemar" or Maupassant's "Un Fou?." Contemporary science fiction, when it does not slip into allegory, obeys the same mechanism: these narratives, starting from irrational premises, link the "facts" they

contain in a perfectly logical manner. (Their plot structure also differs from that of the fantastic tale; we shall discuss science-fiction plots in Chapter 10.)

All these varieties of the marvelous — "excused," justified, and imperfect — stand in opposition to the marvelous in its pure — unexplained — state. We shall not consider it here: first, because the elements of the marvelous, as themes, will be examined below in Chapters 7 and 8; and also because the aspiration to the marvelous, as an anthropological phenomenon, exceeds the context of a study limited to literary aspects. In any case, the marvelous has been, from this perspective, the object of several penetrating books; and in conclusion, I shall borrow from one of these, Pierre Mabille's *Miroir du Merveilleux*, a sentence which neatly defines the meaning of the marvelous:

> Beyond entertainment, beyond curiosity, beyond all the emotions such narratives and legends afford, beyond the need to divert, to forget, or to achieve delightful or terrifying sensations, the real goal of the marvelous journey is the total exploration of universal reality.

4

poetry and allegory

We have seen what dangers beset the fantastic on a first level, where the implicit reader judges certain reported events while identifying himself with a character in the narrative. These dangers are symmetrical and inverse: either the reader admits that these apparently supernatural events are susceptible of a rational explanation, and we then shift from the fantastic to the uncanny; or else he admits their existence as such, and we find ourselves within the marvelous.

But the perils incurred by the fantastic do not stop here. If we move to another level, the one where the implicit reader questions not the nature of the events, but that of the very text which describes them, we find the existence of the fantastic threatened once again. This will lead us to a new problem and, in order to solve it, we must specify the relations of the fantastic with two adjacent genres: *poetry* and *allegory*. The articulation is more complex here than that which controlled the relations of the fantastic to the uncanny and the marvelous. First of all, because the genre which stands in opposition to poetry on the one hand, and on the other to allegory, is not the fantastic alone but in each case a much

larger grouping to which the fantastic belongs. Secondly be-
cause, unlike the uncanny and the marvelous, poetry and alle-
gory do not stand in opposition to each other. Each stands in
opposition to another genre, of which the fantastic is only a
subdivision — another genre which is not the same in both
cases. We must therefore study the two oppositions separately.
 Let us begin with the simpler one: *poetry* and *fiction*.
We remarked at the start of this study that any opposition
between two genres must be based on a structural property
of the literary work. In this case the property in question
is the very nature of discourse, which may or may not be
representative. We must employ this term "representative"
with some caution: literature is not representative in the same
sense that certain sentences of everyday speech may be rep-
resentative, for literature does not refer (in the strict sense
of the verb) to anything outside itself. The events reported
by a literary text are "literary events" and, like the characters,
they are interior to the text. But to deny literature any represen-
tative aspect for this reason is to identify the reference with
the referent, the aptitude to denote objects with the objects
themselves. Further, the representative aspect prevails in a
certain part of literature which it is convenient to designate
by the term *fiction*, whereas *poetry* rejects this aptitude to
evoke and represent (this opposition, moreover, tends to blur
in twentieth-century literature). It is no accident if, in fiction,
the terms commonly employed are: characters, action,
atmosphere, etc., all of which also designate a non-textual
reality. On the other hand, in poetry we are inclined to speak
of rhymes, rhythm, rhetorical figures, etc. This opposition,
like most of those we find in literature, is not an all-or-nothing
affair, but rather one of degree. Poetry too includes certain
representative elements, and fiction properties which render
the text opaque, intransitive. But the fundamental opposition
exists nonetheless.
 Without attempting a historical sketch of the problem
here, we may note that this conception of poetry has not

always been predominant. The controversy was particularly sharp with regard to figures of rhetoric: it was asked whether or not one was to make such figures into images, to shift from formula to representation. Voltaire, for instance, said that "a metaphor, to be a good one, must always be an image; it must be such that a painter might represent it with a brush" (*Remarques sur Corneille*). This naive requirement, which no poet has ever satisfied, has been contested ever since the eighteenth century. But we must wait, at least in France, until Mallarmé before we can begin to take words for words, not for the imperceptible props of images. In contemporary criticism, it is the Russian formalists who first insisted on the intransitivity of poetic images. Shklovsky cites, for example, "Tyutchev's comparison of the dawn to deaf-mute demons, or Gogol's of the sky with God's chasubles." Today it is generally agreed that poetic images are not descriptive, that they are to be read quite literally, on the level of the verbal chain they constitute, not even on that of their reference. The poetic image is a combination of words, not of things, and it is pointless, even harmful, to translate this combination into sensory terms.

We see now why the poetic reading constitutes a danger for the fantastic. If as we read a text we reject all representation, considering each sentence as a pure semantic combination, the fantastic *could not appear*: for the fantastic requires, it will be recalled, a reaction to events as they occur in the world evoked. For this reason, the fantastic can subsist only within fiction; poetry cannot be fantastic (though there may be anthologies of "fantastic poetry"). In short, the fantastic implies fiction.

Generally, poetic discourse is evidenced by many secondary properties that enable us to know at once that in a specific text we must not look for the fantastic; rhymes, regular meter, emotive discourse, etc., dissuade us from doing so. There is not much risk of confusion here. But certain prose texts require different levels of reading. Let us turn to *Aurélia* once

again. Most of the time, the dreams Nerval reports are to be read as fiction, and it is convenient for the reader to represent to himself what they describe as he reads. Here is an example of this type of dream:

> A being of enormous size — man or woman, I don't know which — fluttered laboriously overhead and seemed to be struggling among thick clouds. Breath and strength failing, it fell at last in the center of the dark courtyard, catching and tearing its wings on the roofs and balconies as it fell.

This dream evokes a vision we must take as just that; we are indeed dealing with a supernatural event.

Yet here is another example, from a dream in "Les Mémorables," which illustrates a different attitude toward the text:

> From the depth of the silent shadows, two notes rang out, one low, the other shrill — and the eternal orb began to revolve therewith. Blessed be thou, O first octave which began the divine hymn! From Sunday to Sunday, ensnare each day in your magical net. The mountains chant you to the valleys, the springs to the streams, the streams to the rivers, the rivers to the Ocean; the air vibrates and the light harmoniously dashes against the opening flowers. A sigh, a shudder of love emerges from the swollen heart of the earth, and the crown of stars circles in the infinite heavens, withdraws and returns, contracts and expands, and sows in the remote aether the seeds of new creations.

If we try to transcend the words in order to reach the vision, the vision might be classified in the category of the supernatural: the octave which ensnares the days, the chant of the mountains, the earth's sigh, etc. But here we must not follow such a path: the phrases quoted require a poetic reading, they do not tend to describe an evoked world. Such is the paradox of literary language: it is precisely when words are employed in the figurative sense that we must take them literally.

Thus we are led, by the path of rhetorical figures, to the other opposition which concerns us: the opposition between *allegorical* and *literal* meaning. The word *literal* employed here might have been used, in another sense, to designate the kind of reading we believe proper to poetry. We must be careful not to confuse the two usages: in one case, literal is being opposed to referential, descriptive, representative; in the other, the case that interests us here, literal meaning is being used in opposition to *figurative* meaning — that is, to what we are calling the allegorical sense.

Let us begin by defining allegory. As usual, there is no lack of earlier definitions, which vary from the narrowest to the most inclusive. Curiously, the broadest definition is also the most recent; it is to be found in that veritable encyclopedia of allegory, Angus Fletcher's book *Allegory*: "In the simplest terms, allegory says one thing and means another," Fletcher remarks at the opening of his book. All definitions are, as we know, arbitrary — but this one is anything but alluring: by its generality it transforms allegory into a carry-all, a super-figure.

At the other extreme occurs an equally modern, much more restrictive acceptation of the term, which we might summarize thus: allegory is a proposition with a double meaning, but whose literal meaning has been entirely effaced. Thus in the proverb: "The pitcher goes so often to the well that it is broken at last" — no one, or almost no one, thinks, upon hearing these words, of a pitcher, a well, or the action of breaking: we immediately grasp the allegorical meaning: to run too many risks is dangerous, etc. Thus understood, allegory has often been stigmatized by modern authors as contrary to literality.

Antiquity's notion of allegory will be more useful to us. Quintilian writes: "A continuous metaphor develops into allegory." In other words, an isolated metaphor indicates only a figurative manner of speaking; but if the metaphor is sustained, it reveals an intention to speak of something else

besides the first object of the utterance. This definition is valuable because it is formal, it indicates the means by which we can identify allegory. If, for example, we speak first of the State as a ship, then of the Chief of State as a captain, we can say the nautical imagery affords an allegory of the State.

Fontanier, the last great French rhetorician, writes: "allegory consists in a proposition with two meanings, a literal meaning and a spiritual meaning both together," and illustrates this definition by the following example:

> I prefer a stream which, in a bed of sand,
> Wanders through a meadow filled with flowers,
> To an unchecked torrent which with stormy force
> Flows choked with gravel over muddy ground.

We might take these lines for a naive poetry of dubious merit, if we were unaware that they are from Boileau's *Art Poétique*. What concerns Boileau is assuredly not the description of a stream but of two styles, as Fontanier is careful to explain: "Boileau wants it to be understood that an embellished and orderly style is preferable to an impetuous, unequal, and unruly one." We have no need of Fontanier's commentary, of course, in order to understand this; the mere fact that the lines occur in the *Art Poétique* ensures that words will be taken in their allegorical sense.

Let us recapitulate: first of all, allegory implies the existence of at least two meanings for the same words; according to some critics, the first meaning must disappear, while others require that the two be present together. Secondly, this double meaning is indicated in the work in an *explicit* fashion: it does not proceed from the reader's interpretation (whether arbitrary or not).

With the help of these two conclusions, let us return to the fantastic. If what we read describes a supernatural event, yet we take the words not in their literal meaning but in another

sense which refers to nothing supernatural, there is no longer
any space in which the fantastic can exist. There exists then
a scale of literary sub-genres, between the fantastic (which
belongs to that type of text which must be read literally)
and pure allegory (which retains only the second, allegorical
meaning): a scale constituted in terms of two factors, the
explicit character of the indication and the disappearance of
the first meaning. A few examples will permit us to make
this analysis more concrete.

Fable is the genre that comes closest to pure allegory,
in which the first meaning of the words tends to be completely
effaced. Fairy tales, which habitually include supernatural ele-
ments, sometimes approach fable — as in the case of certain
tales by Perrault. Here allegorical meaning is made explicit
to an extreme degree: we find it summarized, in the form
of a few lines of verse, at the end of each tale. Consider
"Riquet à la Houppe": this is the story of an intelligent but
extremely ugly prince who can make persons of his choice
as intelligent as himself, and of a lovely but stupid princess
who has a similar gift with regard to beauty. The prince makes
the princess intelligent; a year later, after many hesitations,
the princess grants beauty to the prince. These are super-
natural events; but within the tale itself, Perrault suggests
that we are to take the words in an allegorical sense.

> The princess had no sooner uttered these words, than Riquet
> à la Houppe seemed, to her eyes, the finest, shapeliest, and most
> agreeable man of the world she had ever seen. Some say it was
> not at all the fairy's charms that had been at work, but that love
> alone produced this transformation. They say that the princess,
> having reflected upon her lover's perseverence, upon his discre-
> tion, and upon all the good qualities of his mind, no longer saw
> the deformity of his body nor the ugliness of his countenance;
> that his hump seemed to her no more than the posture of a man
> who shrugs his shoulders, and that what she had once called a
> hideous limp she now regarded as no more than a certain inclined
> posture which delighted her. These same people say that his squint-

ing eyes seemed to her only all the more brilliant, and that in consequence their disorder appeared to her the sign of a violent passion; and that finally she regarded his huge red nose as having something martial and heroic about it.

To make sure he has been understood, Perrault adds a moral at the end of his tale:

> What may be discerned in this text
> Is less a tale than truth itself.
> All is beauty in one we love
> And whomever we love is clever.

After these indications, of course, nothing supernatural is left: each of us has received the same power of transformation, and the fairies have nothing to do with it. The allegory is quite as evident in other tales by Perrault. He himself, moreover, was entirely conscious of it, and in the prefaces to his collections deals chiefly with this problem of allegorical meaning, which he considers essential ("the moral, a principal matter in fables of all kinds. . . .")

We must add that the reader (real and not implicit, this time) is entitled not to concern himself with the allegorical meaning suggested by the author, and to discover an entirely different meaning in the text if he chooses to do so. This happens today with Perrault: the contemporary reader is struck by sexual symbolism rather than by the moral promulgated by the author.

Allegorical meaning can appear with the same distinctness in works that are no longer fairy tales or fables, but "modern" tales. Daudet's "L'Homme à la Cervelle d'Or" illustrates this. The tale recounts the misfortunes of a man "whose brain was made of gold." This expression — "made of gold" — is used in the strict and not the figurative sense of "excellent"; nonetheless, from the beginning of the tale, the author suggests that the right meaning is, precisely, the allegorical one. Thus:

"I must confess that I was endowed with an intelligence that astonished people and concerning which only my parents and myself possessed the secret. Who would not have been intelligent with a brain as rich as mine?" This golden brain repeatedly turns out to be its possessor's sole means of obtaining the money he or his family needs; and the story tells how the brain thus is gradually exhausted. Each time a chip of gold is removed from the brain, the author does not fail to suggest the "real" signification of such an act:

> Here, a dreadful objection rose before me: this sliver I was going to tear from my brain — was it not a sliver of my own intelligence of which I was depriving myself? . . . I had to have money: my brain was worth money, and indeed, I spent my brain. . . . What most astonished me was the quantity of wealth my brain contained and the difficulty I had exhausting it [etc.]

Recourse to the brain offers no physical danger, but instead threatens the intelligence. And just as in Perrault, Daudet adds at the end, in case the reader has not yet grasped the allegory:

> Then, while I was lamenting and weeping bitter tears, I happened to think of so many wretches who live by their brains even as I had lived by mine, of those impoverished artists and authors obliged to turn their intelligence into bread, and I reminded myself that I was not the only one in this world to know the sufferings of a man whose brain was made of gold.

In this type of allegory, the level of literal meaning has slight importance; the evident improbabilities do not matter, all our attention is focused on the allegory. We may note that narratives of this kind are rarely enjoyed today: explicit allegory is regarded as sub-literature (and it is difficult to avoid interpreting this condemnation as an ideological stance).

Now let us move one step further: the allegorical meaning remains incontestible, but it is indicated by subtler means

than a "moral" at the end of the text. Balzac's novel *The Magic Skin* affords an example. The supernatural element is the skin itself: first of all because of its extraordinary physical qualities (it resists all experiments to which it is subjected), and then, above all, by its magical powers over the life of its possessor. The skin bears an inscription which explains its power: it is at once an image of its owner's life (its surface corresponds to the length of this life) and a means for him to realize his desires; but each time his desires are fulfilled, the skin shrinks a little. The formal complexity of the image is noteworthy: the magic skin is a metaphor for life, a metonymy for desire, and it establishes a relation of inverse proportion between what it represents in the one case and in the other.

The very precise signification we are to attribute to the skin already invites us not to imprison it within its literal meaning. Further, several characters in the book develop theories in which this same inverse relation appears between length of life and the realization of desires. For instance, the old antique-dealer who gives the skin to Raphael: " 'This,' he said in a strident tone, displaying the wild ass's skin, 'is *will* and *power* united. Here are your social ideas, your excessive desires, your dissipations, your murderous joys, your mortal sufferings.' " This same conception is also defended by Rastignac, Raphael's friend, long before the skin makes its appearance in the story. Rastignac maintains that instead of killing oneself quickly, one might more agreeably waste one's life on pleasure; the result would be the same: "Dissipation, my friend, is the queen of all deaths. Does it not rule even swift apoplexy, that pistol-shot which never misses? Orgies afford us every physical pleasure; are they not a kind of opium, the small change of opium?" Rastignac is really saying the same thing as is signified by the magic skin: desire's realization leads to death. The allegorical meaning of the image is *indirectly* but clearly indicated.

Contrary to what we have seen on the first level of alle-

gory, the literal meaning is not lost here, as evidenced by the fact that the hesitation characteristic of the fantastic is maintained (and we know that this hesitation is located on the level of the literal meaning). The skin's discovery is prepared for by a description of the strange atmosphere prevailing in the old antique-dealer's shop; and subsequently, none of Raphael's desires is realized in an unlikely fashion. The banquet he requests had already been arranged by his friends; the money comes to him in the form of a legacy; the death of his adversary in a duel can be explained by the fear Raphael's own calm provokes; lastly, Raphael's own death is due, apparently, to phthisis and not to supernatural causes. Only the skin's extraordinary properties openly confirm the intervention of the marvelous. Here we have an example in which the fantastic is absent not because of the failure to fulfill the first condition (hesitation between the uncanny and the marvelous) but because of the failure to fulfill the third: the fantastic is effaced by allegory, and by an allegory indirectly indicated.

The same thing occurs in "Véra." Here the hesitation between the two possible explanations, rational and irrational, is maintained (the rational explanation being that of madness), especially by the simultaneous presence of two points of view, Count d'Athol's and the old servant Raymond's. The count believes (and Villiers de l'Isle-Adam wants the reader to believe) that by dint of love and will, death can be vanquished — and the beloved brought back to life. This idea is indirectly suggested many times over:

> D'Athol, indeed, lived utterly unaware of the death of his beloved! For him she was ever-present, so intimately was the young woman's form mingled with his own. . . . Here was a negation of Death raised, ultimately, to an unknown power! . . . It was as if death were playing hide-and-seek, like a child. She felt she was so greatly loved! How *natural* it was. . . . Ah, Ideas are living beings! . . . The count had shaped the form of his beloved out of the air, and this void had to be filled by the one being homogeneous to it, or else the Universe would collapse.

All these expressions clearly indicate the meaning of the super-
natural event to come, Véra's resurrection.

Which greatly weakens the fantastic, especially since the
story begins by an abstract formula that relates it to the first
group of allegories: *"For love is strong as death,* Solomon
has said: yes, its mysterious power is unlimited." The entire
narrative has the effect of being the illustration of an idea;
and thus the fantastic receives a fatal blow.

A third degree in the weakening of allegory is to be found
in the narrative whose reader reaches the point of hesitating
between the allegorical interpretation and the literal reading.
Even though nothing in the text indicates the allegorical mean-
ing, this meaning remains possible. Let us take several exam-
ples. "The Tale of the Lost Reflection" contained in Hoff-
mann's *New Year's Eve* affords one. This is the story of
a young German, Erasmus Spikher, who during a stay in
Italy encounters a certain Giulietta with whom he falls passion-
ately in love, forgetting the wife and child waiting for him
at home. When at last he must leave, the thought of separation
throws him into despair, and the same is true for Giulietta:

> Giulietta clasped Erasmus more tightly to her breast and whis-
> pered: "Leave me your image reflected in this mirror, my love,
> it will never leave me." And when Erasmus seems to hesitate:
> "What! You will not even grant me this dream of yourself, as
> it gleams in the glass!" Giulietta exclaimed, "You who swore
> you belonged to me body and soul! You will not even let your
> image remain with me and accompany me through this life, which
> will henceforth, I know it well, be without pleasure or love, since
> you are abandoning me?" A torrent of tears flowed from her
> lovely black eyes. Then Erasmus exclaimed, in a transport of
> grief and love: "Must I leave you? Very well then, let my reflection
> be yours forever!"

No sooner said than done: Erasmus loses his reflection.
We are here on the level of the literal meaning: henceforth
Erasmus sees absolutely nothing when he looks at himself
in a mirror. But, gradually, during his various adventures,

a certain interpretation of the supernatural event will be suggested. The reflection is sometimes identified with social standing; thus in the course of a journey, Erasmus is accused of having no reflection:

> Consumed with rage and shame, Erasmus withdrew to his room. But no sooner had he entered it, than he was informed by the police that he was to present himself within the hour before the authorities, with his reflection intact and entirely in his own likeness, or else he would have to leave the city.

Similarly, his own wife declares, later on: "Besides, you know that without your reflection you will be a laughing-stock, and that you cannot be a proper father of a family, capable of inspiring respect in his wife and children." That these characters are in no other way astonished by the absence of the reflection (they find it unseemly rather then surprising) leads us to suppose that this absence is not to be taken literally.

At the same time, it is suggested that the reflection simply designates a part of the personality (and in this case, there would be nothing supernatural in losing it). Erasmus himself reacts in this way:

> He sought to prove that it was, in truth, absurd to believe a man could lose his reflection; but that, in any case, it would not be a great loss because any reflection is only an illusion, because the contemplation of oneself leads to vanity, and finally because such an image divides the self into two parts: truth and dream.

Here, it seems, is a hint as to the allegorical meaning that must be given to this lost reflection; but it remains isolated, unsustained by the rest of the text. The reader is therefore entitled to hesitate before adopting it.

Poe's "William Wilson" offers a similar example, and apropos of the same theme, moreover. This is the story of a man persecuted by his own double. It is difficult to decide if this double is a flesh-and-blood human being or if the author

is offering a parable in which the so-called double is only a part of his personality, a sort of incarnation of his conscience. The latter interpretation is reinforced, in particular, by the utterly improbable resemblance of the two men. They bear the same name and birthdate; they had entered school on the same day; their appearance and even their way of walking are identical. The only important difference — but does this too not have an allegorical signification? — is in their voices: "my rival had a weakness in the faucal and guttural organs, which precluded him from raising his voice at any time *above a very low whisper*." Not only does this double appear, as though by magic, at every important juncture of William Wilson's life ("He who thwarted my ambition at Rome, my revenge at Paris, my passionate love at Naples, or what he falsely termed my avarice in Egypt"), but he may be identified by external attributes whose coincidental existence would be difficult to explain. For example, the cloak during the scandal at Oxford:

> The cloak which I had worn was of a rare description of fur; how rare, how extravagantly costly, I shall not venture to say. Its fashion, too, was of my own fantastic invention. . . . When, therefore, Mr. Preston reached me that which he had picked up upon the floor, and near the folding-doors of the apartment, it was with an astonishment nearly bordering upon terror that I perceived my own already hanging on my arm (where I had no doubt unwittingly placed it), and that the one presented to me was but its exact counterpart in every, in even the minutest possible particular.

The coincidence is, as we note, exceptional — unless we decide that there are perhaps not two cloaks but only one.

The end of the story impels us toward an allegorical meaning. William Wilson provokes his double to a duel and wounds him mortally. Then "the other," staggering, speaks to him: "You have conquered, and I yield. Yet henceforward art thou also dead — dead to the World, to Heaven, and to Hope!

In me didst thou exist — and, in my death, see by this image, which is thine own, how utterly thou hast murdered thyself!'' These words seem to make the allegory quite explicit; nonetheless they remain significant and relevant on the literal level. We cannot say we are dealing here with a pure allegory; instead we are confronting a hesitation on the part of the reader.

Gogol's story "The Nose" constitutes a limit-case. This narrative does not observe the first condition of the fantastic, that hesitation between the real and the illusory or imaginary be present, and it is therefore situated from the start within the marvelous (a nose detaches itself from its owner's face and, having become a person, leads an independent life; then it returns to its place). But several other properties of the text suggest a different perspective, more particularly that of allegory. For instance the metaphorical expressions which reintroduce the word *nose*: it is made into a proper name (Mr. Nosov); Kovaliov, the hero, is told that a suitable man would not be deprived of his nose; finally, the word "nose" is transformed into the Russian expression for non-plussed. The reader is thus given some reason to wonder if, elsewhere too, the *nose* might not have a different meaning from its literal one. Further, the world Gogol describes is not at all a world of the marvelous as we might have expected it would be. It is, on the contrary, the life of Saint Petersburg down to its most mundane details. Since the supernatural elements are therefore not here to evoke a universe different from our own, we are tempted to search out an allegorical interpretation for them.

But having reached this point, the perplexed reader stops. The psychoanalytic interpretation (the disappearance of the nose signifies, we are told, castration), even if it were satisfactory, would not be allegorical, for nothing in the text explicitly suggests that we make it so. Further, this interpretation fails to explain the transformation of the nose into a person. The same applies to social allegory (here the lost nose would mean the same as the lost reflection in Hoffmann). There are, it

is true, more indications in its favor, but it does not account for the central transformations any better than the psychoanalytic interpretation. Elsewhere, events produce on the reader an impression of the gratuitous that contradicts one requirement of allegorical meaning. This contradictory sentiment is emphasized by the conclusion. Here the author addresses the reader directly, rendering explicit the reader's function, which is inherent in the text, and thereby even facilitating the appearance of an allegorical meaning. But at the same time, what he asserts is that this meaning cannot be found. "But what is stranger, what is more incomprehensible than anything is that authors can choose such subjects. . . .In the first place, it is absolutely without advantage to our country; in the second place. . . but in the second place, too, there is no advantage." The impossibility of attributing an allegorical meaning to the tale's supernatural elements returns us to the literal meaning. On this level, "The Nose" becomes a pure incarnation of the absurd, of the impossible: even if we accepted the transformations, we could not explain the absence of reaction on the part of the characters who witness them. What Gogol asserts is, precisely, non-meaning.

"The Nose" therefore raises the problem of allegory in a double sense. On the one hand, it shows that one may produce the impression that there is an allegorical meaning when there is, in fact, no allegorical meaning present. On the other hand, in describing the metamorphoses of a nose, it narrates the adventures of allegory itself. By these properties, and several others as well, "The Nose" anticipates what the literature of the supernatural will become in the twentieth century (Chapter 10).

To summarize our exploration: we have distinguished several degrees, from obvious allegory (Perrault, Daudet) to illusory allegory (Gogol), passing through indirect allegory (Balzac, Villiers de l'Isle-Adam) and "hesitating" allegory (Hoffmann, Poe). In each case, the fantastic is called into question. We must insist on the fact that we cannot speak

of allegory unless we find explicit indications of it within the text. Otherwise, we shift to what is no more than a reader's interpretation; and at this point every literary text would be allegorical, for it is the characteristic factor of literature to be endlessly interpreted and reinterpreted by its readers.

5

discourse of the fantastic

We have just located the fantastic in relation
to two other genres, poetry and allegory. Not all fictions
and not all literal meanings are linked to the fantastic; but
the fantastic is always linked to both fiction and literal meaning.
They are therefore necessary conditions for the existence of
the fantastic.

We may now take our definition of the fantastic to be
complete and explicit. What remains to be done, when we
study a genre? To answer this question, we must revert to
one of the premises of our analysis, briefly mentioned in the
initial discussion. We postulate that every literary text func-
tions in the manner of a system; which implies that there
exist necessary and not arbitrary relations between the con-
stitutive parts of this text. Cuvier, it will be recalled, had
provoked the admiration of his contemporaries by reconstruct-
ing the image of an animal starting from a single vertebra.
Knowing the structure of a literary work, one ought to be
able, given the knowledge of a single feature, to reconstruct
all the rest. Moreover the analogy is valid precisely on the
level of genre: Cuvier, too, claimed to define the species,
not the individual animal.

Granted this postulate, it is easy to understand why our task is not completed. It is not possible for one of the features of a work to be fixed without all the others being influenced by it. We must therefore discover how the choice of this one feature affects the others, reveal its repercussions. If the literary work truly forms a structure, we must find on every level consequences of that ambiguous perception by the reader which characterizes the fantastic.

When we pose this requirement, we must at the same time avoid the excesses into which several authors have lapsed in treating the fantastic. Some, for example, have presented *all* the features of the work as obligatory, down to the last detail. In Penzoldt's book on the fantastic, for instance, we find a detailed description of the Gothic novel which even specifies the presence of trap doors and catacombs, alludes to the medieval setting, the passivity of the ghost, etc. Such details may be historically accurate, and it is not a question of denying the existence of an organization on the level of the initial literary "signifier"; but it is difficult (at least given the present state of our information) to find a theoretical justification for them. One may study such details apropos of particular works, but not from the perspective of genre. We shall limit ourselves here to the rather general features for which we can supply a structural basis. Moreover, we shall not grant the same attention to every aspect: we shall briefly review several features of the work which relate to its verbal and syntactical aspects, whereas the semantic aspect will concern us throughout our investigation.

Let us begin with three properties which show particularly well how structural unity is achieved. The first derives from the utterance; the second from the act of uttering (or speech act); the third from the syntactical aspect.

The first of these features is a certain use of figurative discourse. The supernatural often appears because we take

a figurative sense literally. Indeed, rhetorical figures are linked
to the fantastic in several ways, and we must distinguish these
relations.

We have already spoken of the first, apropos of the
"hyperbolic marvelous" in the *Arabian Nights*. The super-
natural may sometimes originate in a figurative image, may
be its ultimate extension — as in the case of the huge serpents
or birds in Sinbad's stories; we shift, in this case, from hyper-
bole to the fantastic. In Beckford's *Vathek* we encounter a
systematic use of this procedure: here the supernatural appears
as an extension of a rhetorical figure. Consider some examples
drawn from the description of life in Vathek's palace. This
caliph offers a great reward to the decipherer of an inscription;
but to forestall the incompetent, he decrees that "those who
fail upon trial shall have their beards burnt off to the last
hair." With what result?

> The learned, the half learned, and those who were neither, but
> fancied themselves equal to both, came boldly to hazard their
> beards, and all shamefully lost them. The exaction of these forfei-
> tures, which found sufficient employment for the eunuchs, gave
> them such a smell of singed hair as greatly to disgust the ladies
> of the seraglio, and to make it necessary that this new occupation
> of their guardians should be transferred to other hands.

Exaggeration leads to the supernatural. Here is an
instance: the caliph is condemned by the devil to be eternally
thirsty — but Beckford is not content to say that the caliph
swallows a great deal of liquid, but evokes a quantity of water
which leads us to the supernatural.

> So insatiable was the thirst that tormented him, that his mouth,
> like a funnel, was always open to receive the various liquors that
> might be poured into it; his attendants ... assiduously employed
> themselves in filling capacious bowls of rock crystal, and emu-
> lously presenting them to him. But it frequently happened that
> his avidity exceeded their zeal, insomuch that he would prostrate

himself upon the ground to lap the water, of which he could never have enough.

The most eloquent example is that of the Indian who turns himself into a ball. The situation is as follows. The Indian, a disguised minor devil, has participated in the caliph's repast, but has behaved so badly that Vathek cannot restrain himself.

Vathek, no longer able to brook such insolence, immediately kicked him from the steps; instantly descending, repeated his blow; and persisted, with such assiduity, as incited all who were present to follow his example. Every foot was up and aimed at the Indian, and no sooner had any one given him a kick, than he felt himself constrained to reiterate the stroke. The stranger afforded them no small entertainment; for being both short and plump, he huddled into a ball, and rolled on all sides at the blows of his assailants, who pressed after him, wherever he turned, with an eagerness beyond conception. The ball, indeed, in passing from one apartment to another, drew every person after it that came its way.

Thus the expression "huddled into a ball" leads to a veritable metamorphosis (how else are we to conceive this rolling from room to room?), and the pursuit gradually assumes gigantic proportions.

After having traversed the halls, galleries, chambers, kitchens, gardens, and stables of the palace, the Indian at last took his course through the courts; whilst the Caliph, pursuing him closer than the rest, bestowed as many kicks as he possibly could; yet not without receiving now and then a few which his competitors, in their eagerness, designed for the ball. . . . The sight of this fatal ball was alone sufficient to draw after it every beholder. The Muezzins themselves, though they saw it but at a distance, hastened down from their minarets, and mixed with the crowd, which continued to increase in so surprising a manner that scarcely an inhabitant was left in Samarah except the aged, the sick, confined to their beds, and infants at the breast, whose nurses could run more nimbly without them. . . . At last, the cursed Indian,

who still preserved his rotundity of figure, after passing through all the streets and public places, and leaving them empty, rolled onwards to the plain of Catoul, and entered the valley at the foot of the mountain of the four fountains.

This example introduces us to a second relation of rhetorical figures with the fantastic: here the fantastic realizes the literal sense of a *figurative* expression. We have seen one example of this at the beginning of "Véra": the narrative takes literally the expression "love is strong as death." The same method is employed in Potocki. Here is an episode from the story of Landolfo of Ferrara:

> The poor woman was with her daughter, about to sit down to dinner. When she saw her son enter, she asked him if Blanca would come and dine [as it happens, Blanca, Landolfo's mistress, has just been murdered by the mother's brother]. "Would that she came," Landolfo said, "and took you down to hell, with your brother and the whole Zampi family!" The poor mother fell to her knees and exclaimed: "O my God, forgive him his blasphemies!" At this moment, the door opened with a tremendous noise, and on the threshold appeared a haggard spectre, torn with dagger-blows and yet preserving a dreadful resemblance to Blanca.

Thus the simple curse, whose initial meaning is no longer perceived habitually, turns out to be taken literally.

But it is a third use of rhetorical figures that will concern us most: in the two preceding cases, the figure was the source, the origin of the supernatural element; the relation between them was diachronic. In the third case, the relation is synchronic: the figure and the supernatural are present on the same level, and their relation is functional, not "etymological." Here the appearance of the fantastic element is preceded by a series of comparisons, of figurative or simply idiomatic expressions, quite common in ordinary speech but designating, if taken literally, a supernatural event — the very one that will occur at the end of the story. This happens in "The Nose," as has been mentioned; but there are countless

examples elsewhere. Let us take Mérimée's "La Vénus d'Ille." The supernatural event in this work occurs when a statue comes to life and kills in its embrace a bridegroom who has been imprudent enough to leave his wedding ring on its finger. Here is how the reader is "conditioned" by the figurative expressions that precede the event. One of the peasants describes the statue: "She fixes you with her huge white eyes. . . . It is as if she were staring right at you." To say of a portrait's eyes that they seem to be alive is banality; but here the cliché prepares us for a real "animation." Later on, the bridegroom explains why he will not send anyone to get the ring he has left on the statue's finger: "Moreover, what would people think of my absent-mindedness? . . . They would call me the statue's husband." Once again, a simple figurative expression — but at the tale's end, the statue will indeed behave as if it were Alphonse's bride. And after the accident, here is how the narrator describes Alphonse's dead body: "I opened his shirt and saw upon his chest a livid mark which extended over the ribs and back. It was as if he had been embraced in a circle of iron." *It was as if:* now this is precisely what the supernatural interpretation suggests. Similarly, this time in the bride's account after the fatal night, we are told that "someone came in. . . . A moment later, the bed groaned as if it were loaded with an enormous weight." Each time, as we see, the figurative expression is introduced by a modalizing formula: "he seemed," "they would call me," "as if."

This method is not at all exclusive to Mérimée; we find it in almost all the authors of the fantastic. Thus in "Inès de las Sierras," Nodier describes the appearance of a strange being we are to take for a spectre in this way: "Nothing was left in this physiognomy that belonged to earth. . . ." If this were truly a spectre, it must be the one which, in the legend, punishes its enemies by placing a burning hand over their hearts. What is it, in fact that Inès does? " 'Very well,' Inès said, throwing one of her arms around Sergy's

neck and pressing against his heart a hand as fiery as the one spoken of in the legend of Estéban." The comparison is doubled by a "coincidence." The same Inès, a spectre in her powers, does not stop at this: " 'A miracle!' she added suddenly. 'Some kindly demon has slipped castanettes into my girdle. . . . ' "

The same procedure is employed in Villiers de l'Isle-Adam's "Véra": "In them, spirit penetrated the body so deeply that their forms seemed intellectual. . . . The pearls were still warm and their luster dimmed, as though by the warmth of flesh. . . . That evening, the opal gleamed as if it had just been taken off. . . ." The suggestions of resurrection are introduced by "as if" or "as though."

The method is also used in Maupassant's "La Chevelure," when the narrator discovers a lock of hair in the secret drawer of a desk; soon he has the impression that this lock is not truly severed, but that the woman to whom it belongs is also present. Here is how the apparition is prepared: "An object . . . attracts you, disturbs you, invades your mind the same way a woman's face might." Again: "You caress it with your eye and your hand as if it were flesh and blood . . . you contemplate it with a lover's tenderness." Thus we are prepared for the "abnormal" love which the narrator will bestow upon this inanimate object, the lock of hair. Here too we note the use of "as if."

In the same author's "Qui Sait?," "The great clump of trees looked like a tomb in which my house was buried" — thus we are introduced at the start into the tale's sepulchral atmosphere. Later on: "I advanced the way a knight of those remote ages entered into a realm of magical spells." Now, it is precisely a realm of magical spells that we are entering at this moment. The number and variety of the examples clearly show that we are not concerned here with an individual feature of style, but with a property linked to the structure of the fantastic as a genre.

The different relations that we have observed between

the fantastic and figurative discourse shed light on each other. If the fantastic constantly makes use of rhetorical figures, it is because it originates in them. The supernatural is born of language, it is both its consequence and its proof: not only do the devil and vampires exist only in words, but language alone enables us to conceive what is always absent: the supernatural. The supernatural thereby becomes a symbol of language, just as the figures of rhetoric do, and the figure is, as we have seen, the purest form of literality.

The use of figurative discourse is a feature of utterance; let us now turn to the act of uttering, or speech act, and more exactly to the narrator's problem, in order to observe a second structural property of the fantastic narrative. In stories of the fantastic, the narrator habitually says "I." This is an empirical fact which we may readily verify. *Le Diable Amoureux, The Saragossa Manuscript, Aurélia*, Gautier's tales and those of Poe, "La Vénus d'Ille," "Inès de las Sierras," the stories of Maupassant, certain narratives by Hoffmann: all of these works conform to the rule. The exceptions are almost always texts which, from several other points of view, withdraw from the fantastic.

In order to understand this phenomenon properly, we must return to one of our premises, the one concerning the status of literary discourse. Though the sentences of a literary text generally have an assertive form, they are not true assertions, for they do not satisfy one essential condition: the test of truth. In other words, when a book begins with a sentence like "John was in the room, lying on his bed," we are not entitled to ask ourselves if this is true or false. Such a question has no meaning, for literary language is a conventional language in which the test of truth is impossible. Truth is a relation between words and the things that the words designate; now, in literature, these "things" do not exist. On the other hand, literature does admit a requirement of validity or inter-

nal coherence: if on the next page of the same imaginary book, we are told there is no bed in John's room, the text does not fulfill the requirement of coherence, and thereby makes that requirement a problem, introduces it into its thematics as a problem. This is not possible with regard to truth. We must also be careful not to confuse the problem of truth with that of representation: *only* poetry rejects representation, but *all* literature escapes the category of the true and the false.

It is convenient to introduce one more distinction within the work itself: only what is given in the author's name in the text escapes the test of truth; the speech of the characters can be true or false, as in everyday life. The detective story, for example, plays constantly on the false testimony of the characters. The problem becomes more complex in the case of a narrator-character — a narrator who says "I." As narrator, his discourse is not subject to the test of truth; but as a character, he can lie. This double game has been exploited, as we know, in one of Agatha Christie's novels, *The Murder of Roger Ackroyd*, in which the reader never suspects the narrator — forgetting that he too is a character.

The represented ("dramatized") narrator is therefore quite suitable to the fantastic. He is preferable to the simple character, who can easily lie, as we shall see in several examples. But he is also preferable to the non-represented narrator, and this for two reasons. First, if a supernatural event were reported to us by such a narrator, we should immediately be in the marvelous; there would be no occasion, in fact, to doubt his words. But the fantastic, as we know, requires doubt. It is no accident that tales of the marvelous rarely employ the first person (it is not found either in the *Arabian Nights*, or Perrault's tales or those of Hoffmann, nor is it used in *Vathek*). They have no need of it; their supernatural universe is not intended to awaken doubts. The fantastic confronts us with a dilemma: to believe or not to believe? The marvelous achieves this impossible union, proposing that the reader believe without really believing. Secondly, and this

is related to the very definition of the fantastic, the first-person narrator most readily permits the reader to identify with the character, since as we know the pronoun "I" belongs to everyone. Further, in order to facilitate the identification, the narrator will be an "average man," in whom (almost) every reader can recognize himself. Thus we enter as directly as possible into the universe of the fantastic. The identification we refer to here must not be mistaken for an individual psychological function: it is a mechanism internal to the text, a structural concomitant. Obviously, nothing prevents the actual reader from keeping his distance in relation to the universe of the work.

Several examples will prove the effectiveness of this procedure. The entire "suspense" of a tale like "Inès de Las Sierras" is based on the fact that the inexplicable events are narrated by someone who is one of the heroes of the story as well as its narrator: he is a man like anyone else, his language is doubly worthy of confidence. In other words, the events are supernatural, the narrator is natural. These are excellent conditions for the appearance of the fantastic. Similarly, in "La Vénus d'Ille" (which tends more toward the fantastic-marvelous, whereas we were in the fantastic-uncanny with Nodier), if the fantastic appears, it is precisely because the indications of the supernatural — the marks left by the embrace, the sound of footsteps on the stairs, and above all the discovery of the ring in the bedroom — are observed by the narrator himself, an archeologist worthy of confidence, steeped in the certitudes of science. The narrator's role in these two tales somewhat recalls that of Watson in Conan Doyle's novels, or that of his numerous avatars: witnesses rather than actors, in whom it is possible for every reader to recognize himself.

Thus in "Inès de las Sierras" as in "La Vénus d'Ille," the narrator-character facilitates *identification*. Other examples illustrate the first function we set forth: to *authenticate* what is narrated, though without an obligation to accept the

supernatural definitively. Take for instance the scene in *Le Diable Amoureux* where Soberano gives proof of his magical powers:

He raises his voice: "Caldéron," he says "get my pipe, light it, and bring it back to me." No sooner has he uttered his command than I see the pipe vanish; and before I can figure out how this was done, or ask who this obedient Caldéron was, the lit pipe was back, and my interlocutor had resumed his occupation.

Similarly, in Maupassant's "Un Fou?":

There was a sort of dagger on my desk which I used for cutting the pages of books. He stretched out his hand, which seemed to creep toward it, and all of a sudden I saw, yes, I saw the knife itself tremble, then it stirred, then it slid gently, of its own accord, across the wood toward the motionless hand waiting for it, and took its place between its fingers. I began to shriek with terror.

In each of these examples, we do not doubt the narrator's testimony. Instead we seek, with him, a rational explanation for these bizarre phenomena.

A character can lie, the narrator must not. That is the conclusion we may draw from Potocki's tales. We have two narratives concerning the same event, the night Alfonso has spent with his two cousins: Alfonso's narrative, which does not contain supernatural elements; and that of Pascheco, who sees the two cousins turn into corpses. But whereas Alfonso's narrative (almost) cannot be false, Pascheco's may be nothing but lies, as Alfonso suspects (with reason, as we learn later on). Or again, Pascheco may have had visions, may be mad, etc. But not Alfonso, insofar as he is identified with the "normal" situation of the narrator.

Maupassant's tales illustrate the different degrees of confidence that we grant to narratives. We may distinguish two, depending on whether the narrator is external to the story

or is one of its principal agents. If external, he may or may not authenticate the words of the character, and in the former case he makes the narrative more convincing, as in the passage quoted from "Un Fou?." Otherwise, the reader will be tempted to explain the fantastic by madness, as in "La Chevelure" and in the first version of "Le Horla" — especially since the context of the narrative is in each case an asylum.

But in his best fantastic tales — "Lui?," "La Nuit," "Le Horla," "Qui Sait?" — Maupassant makes the narrator the hero of the story, just as Poe and many others after him have done. Emphasis is then put on the fact that we are concerned with the discourse of a character rather than with a discourse of the author: language is subject to doubt, and we can well imagine that all these characters are mad; nonetheless, because they are not introduced by a discourse distinct from that of the narrator, we still lend them a paradoxical confidence. We are not told that the narrator is lying, and the possibility that he is lying shocks us "structurally"; but this possibility exists — since he is also a character — and hesitation is thereby generated in the reader.

To sum up: the represented (or "dramatized") narrator is suitable for the fantastic, for he facilitates the necessary identification of the reader with the characters. This narrator's discourse has an ambiguous status, and authors have variously exploited it, emphasizing one or another of its aspects: as the narrator's, the discourse lies outside the test of truth; as the character's it must pass this test.

The third structural feature of the work that concerns us here has to do with its syntactical aspect. Under the name of composition (or even of "structure" in a very loose sense), this aspect of the fantastic narrative has often attracted critical attention. We find a thorough study of it in Penzoldt's book, which devotes an entire chapter to it. Here, in résumé, is Penzoldt's theory: *the structure of the ideal ghost story may*

be represented as a rising line which leads to the culminating point . . . which is obviously the appearance of the ghost. Most authors try to achieve a certain gradation in their ascent to this culmination, first speaking vaguely, then more and more directly.

This theory of the plot in fantastic narrative is derived from the one Poe had proposed for the tale in general. For Poe, the tale is characterized by the existence of a single effect, located at the end, and by the obligation all the elements within the tale are under to contribute to this effect. "In the whole composition, there should be no word written of which the tendency, direct or indirect, is not to the one pre-established design."

We may cite examples confirming this rule. Let us take Mérimée's "La Vénus d'Ille." The final effect (or culminating point, as Penzoldt calls it) is the animation of the statue. From the start, various details prepare us for this event; and from the viewpoint of the fantastic, these details form a perfect gradation. As we have just seen, in the first pages, a peasant reports the discovery of the statue and characterizes it as a living being (she is "nasty," "she glares at you"). Then comes the description of the statue's actual aspect, ending with "a certain illusion which suggested reality, life itself." At the same time, other themes of the narrative are developed: Alphonse's profanatory marriage, the statue's voluptuous form. Then comes the story of the ring, accidentally left on the ring-finger of the Venus: Alphonse cannot manage to remove it. "The Venus has tightened her finger," he declares, in conclusion, "apparently she's my wife now." From this point on, we are confronted with the supernatural, though it remains outside the field of our vision: the footsteps that make the stairway creak, "the bed whose boards are broken," the marks on Alphonse's body, the ring in his room, "some footsteps imprinted deep in the earth," the bride's narrative, and finally the proof that the rational explanations are not satisfactory. The apparition has thus been carefully prepared,

and the statue's animation follows a regular gradation. First it had simply the expression of a living being, then a character asserts that it has tightened its finger, at the end it seems to have killed this same character.

But other fantastic tales do not admit of such a gradation. Let us consider Gautier's "La Morte Amoureuse." Until Clarimonde's first appearance in the dream in this tale, there is a certain gradation, though an imperfect one. But afterwards, the events which occur are neither more nor less supernatural — until the dénouement, which is the decomposition of Clarimonde's corpse. Similarly in the case of Maupassant's tales: the culminating point of the fantastic in "Le Horla," is not the end at all, but rather the first appearance. "Qui Sait?" presents still another organization: here, in fact, there are no preparations for the fantastic before its abrupt intrusion (what precedes it is rather an indirect psychological analysis by the narrator); after which the event occurs: the furniture leaves the house of its own accord. Then the supernatural element disappears for a certain period; reappears, but weakened, during the discovery of the furniture in the antique shop; and regains all its powers just before the end, during the return of the furniture to the house. The very end, however, contains no further supernatural element; it is nonetheless experienced by the reader as a culminating point. Penzoldt, moreover, notes a similar construction in one of his analyses, and concludes: "We can represent the structure of such tales not as the usual line rising to a single culmination, but as a horizontal line which, after having risen briefly during the introduction, remains at a level just below that of the usual culminating point." But such a remark obviously invalidates the generality of the preceding law. (We may note in passing the tendency common to all formalist critics to represent the work's structure by spatial figures.)

These analyses lead to the following conclusion: there does indeed exist a feature of fantastic narrative which is obligatory, but it is more general than Penzoldt initially

described it to be; and it is not a matter of gradation at all. Further, we must explain why this feature is necessary to the genre of the fantastic.

Let us turn back once again to our definition. The fantastic, unlike many other genres, includes *numerous* indications as to the role the reader must play (not that any text fails to do as much). We have seen that this feature derives, more generally, from the process of uttering as it is presented within the text itself. Another important constitutent of this process is its temporality: every work contains an indication as to the time of its perception; the narrative of the fantastic, which strongly emphasizes the process of uttering, simultaneously emphasizes this time of the reading itself. Now, the first characteristic of this reading time is to be, by convention, irreversible. Every text includes an implicit set of directions: that we must read it from its beginning to its end, from the top of the page to the bottom. Not that there are not certain texts which oblige us to modify this order — but such a modification assumes its meaning precisely in relation to the convention which reading from left to right implies. The fantastic is a genre which emphasizes this convention more distinctly than the others.

We are to read an ordinary (non-fantastic) novel, a novel by Balzac, for instance, from beginning to end. But if, by whim, we read the fifth chapter before the fourth, the loss suffered is not so great as if we were reading a fantastic narrative. If we know the end of a fantastic narrative before we begin it, its whole functioning is distorted, for the reader can no longer follow the process of identification step by step; now, this is the first condition of the genre. Moreover, it is not necessarily a question of a gradation, even if this figure, which implies the notion of time, is frequent: in "La Morte Amoureuse" as in "Qui Sait?" there is irreversibility of time without gradation.

Hence the first and the second reading of a fantastic story produce very different impressions (much more than for other

types of narrative). Indeed, for the second reading, identification is no longer possible, and the reading inevitably becomes a meta-reading, in the course of which we note the methods of the fantastic instead of falling under its spell. Nodier, who knew this, made the narrator of "Inès de las Sierras" say at the story's end: "I am not capable of lending it sufficient charm for it to be heard twice over."

We may note, lastly, that the narrative of the fantastic is not the only one to emphasize the work's time of perception: the detective story is even more emphatic in this regard. Since there is a truth to be discovered, we shall be confronted with a strict chain or series, no one link of which can be shifted; for this very reason, and not because of a possible weakness in the writing, we do not reread detective novels. Jokes seem to be under similar constraints. Freud's description applies closely to all genres of emphatic temporality:

> This characteristic of jokes (which determines the shortness of their life and stimulates the constant production of new jokes) is evidently due to the fact that the very nature of surprising someone or taking him unawares implies that it cannot succeed a second time. When a joke is repeated, the attention is led back to the first occasion of hearing it as the memory of it arises.

Surprise is only a particular case of irreversible temporality: thus the abstract analysis of verbal forms permits us to discover relationships where a first impression did not even suggest their existence.

6

themes of the fantastic: introduction

We must now turn to the third aspect of the work, which we have called semantic or thematic, and which we shall now consider at some length. Why should emphasis be placed on this particular aspect? The answer is simple. The fantastic is defined as a special *perception* of uncanny events, and having described this perception at some length, we must now examine in detail the other part of the formula: the uncanny events themselves. Now, by calling an event uncanny, we designate a phenomenon of semantic order. The distinction between syntax and semantics, as it is considered here, can be made explicit in the following way: an event will be considered as a syntactical element insofar as it belongs to a larger figure, insofar as it sustains relations of contiguity with other more or less proximate elements. On the other hand, the same event will be considered as a semantic element once we compare it to other, similar or contrasting elements without these having an immediate relation to the first. Semantics is generated by the paradigmatic, just as syntax is based on the syntagmatic. In speaking of an *uncanny* event, we do not take into account its relations with the contiguous events, but its connections to other events, remote in the series but similar or contrasting.

Ultimately, the fantastic text may or may not be characterized by a certain composition, by a certain "style." But without "uncanny events," the fantastic cannot even appear. The fantastic does not consist, of course, of these events, but they are a necessary condition for it. Hence our attention to them.

We might deal with the problem in another way, starting from the *functions* which the fantastic has in the work. Suppose we ask: what do its fantastic elements contribute to a work? Adopting this functional viewpoint, we find three answers. First, the fantastic produces a particular effect on the reader — fear, or horror, or simply curiosity — which the other genres or literary forms cannot provoke. Second, the fantastic serves the narration, maintains suspense: the presence of fantastic elements permits a particularly dense organization of the plot. Third, the fantastic has what at first glance appears to be a tautological function: it permits the description of a fantastic universe, one that has no reality outside language; the description and what is described are not of a different nature.

The existence of three and only three functions (at this level of generality) is not an accident. The general theory of signs — and we know that literature belongs to the field of this theory — tells us that a sign has three possible functions. The pragmatic function corresponds to the relation between signs and their users; the syntactical function deals with the relation of signs with each other; the semantic function deals with the relation of signs with what they designate, with their reference.

We shall not concern ourselves here with the first function of the fantastic, for it derives from a psychology of reading quite alien to the strictly literary analysis we are undertaking. As for the second, we have already indicated certain affinities between the fantastic and composition, and we shall return to them at the end of this study. It is the third function that we shall deal with, here concerning ourselves with the study of a particular semantic universe.

We can supply an immediate and simple answer to our question (what does the fantastic contribute to a work?) but it is one which does not reach the heart of the matter. It is reasonable to assume that what the fantastic speaks of is not qualitatively different from what literature in general speaks of, but that in doing so it proceeds at a different intensity, this intensity being at its maximum in the fantastic. In other words, and here we return to an expression already used apropos of Poe, the fantastic represents an experience of limits. Let there be no mistake: this expression still explains nothing. To speak of the "limits" — which may be of a thousand kinds — of a continuum of which we know nothing, is to remain quite uninformed. Nevertheless, this hypothesis furnishes us two useful indications: first of all, any study of the themes of the fantastic finds itself in a relation of contiguity with the study of literary themes in general; secondly, the superlative, the excessive, will be the norm of the fantastic. We shall try to keep this in mind throughout.

A typology of the themes of the fantastic will thus be homologous with the typology of literary themes in general. Instead of delighting on this fact, we can only deplore it. For here we touch upon the most complex, the murkiest problem of all literary theory: *how to speak about what literature speaks about?*

By schematizing the problem, one might say that there are two symmetrical dangers to be avoided. The first would reduce literature to pure content (in other words, would be concerned only with its semantic aspect); this attitude would tend to ignore literary specificity, would put literature on the same level, for instance, as philosophical discourse; we would study themes, but they would no longer have anything literary about them. The second, converse danger would reduce literature to pure "form," would deny the pertinence of the themes for literary analysis. On the excuse that only the signifier counts in literature, we would refuse to perceive the semantic aspect (as if the work did not signify on all its many levels).

It is easy to see how each of these options is unacceptable:

what we say is as important in literature as the *way* in which we say it, the "what" matters as much as the "how" and conversely (supposing — as we do not suppose — that the two can be distinguished). But we must not imagine that the right attitude is to be found in a balanced mixture of the two tendencies, in a reasonable proportion of a study of forms and a study of content. The very distinction between form and content must be transcended (this remark is banal enough on the theoretical level, but it retains all its immediacy if we consider individual critical studies today). One of the *raisons d'être* of the concept of structure is just this: to transcend the old dichotomy of form and content, in order to consider the work as a totality and a dynamic unity.

In the conception of the literary work as we have hitherto proposed it, the concepts of form and content have not appeared. We have spoken of several aspects of the work, each of which possesses its structure and still signifies; none is pure form or pure content. It may be objected that the verbal and syntactical aspects are more "formal" than the semantic aspect — it is possible to describe them without naming the meaning of a particular work; on the other hand, when you speak of the semantic aspect, you cannot help concerning yourself with the meaning of the work and hence causing a content to appear.

We must now get rid of this misunderstanding, especially since by doing so we may better define the task which still lies ahead. One must not confuse the study of themes, as we understand it here, with the critical interpretation of a work. We consider the literary work as a structure that can receive any number of interpretations. These depend on the time and place of their formulation, on the critic's personality, on the contemporary configuration of aesthetic theories, etc. Our task, on the other hand, is the description of that hollow structure impregnated by the interpretations of critics and readers. We shall remain as far from the interpretation of individual works as we were in dealing with the verbal or syntactical aspect. As before, we are concerned here as well

to describe a configuration rather than to name a meaning.

It appears that if we accept the contiguity of fantastic themes with literary themes in general, our task becomes one of extreme difficulty. If we possessed a total theory concerning the work's verbal and syntactical aspects, such a theory could include our observations on the fantastic. Here, on the contrary, we possess nothing. And for this very reason, we must pursue two goals at once: to study the themes of the fantastic, and to propose a general theory of the study of themes.

In asserting that no general theory of themes exists, we seem to be forgetting a critical tendency which nonetheless enjoys the greatest prestige today: thematic criticism. It is necessary to say how the method elaborated by this school fails to satisfy us. I shall take as an example several texts by Jean-Pierre Richard, who is certainly its most brilliant representative. These texts are chosen tendentiously, and I make no claims to do justice here to a critical *oeuvre* of crucial importance. Hence I shall limit myself to several of his early prefaces, noting in passing that Richard's more recent texts show that his ideas have evolved in the meantime. What is more, even in the earlier texts, the problems of method turn out to be much more complex once one studies the concrete analyses in greater detail than the present essay can afford.

First of all, it must be said that the use of the term "thematic" is in itself contestable. One might expect, indeed, to find under this heading a study of all themes, whatever they might be. Yet it turns out that the critics make a choice among the possible themes, and it is this choice which best defines their attitude: one might characterize this attitude as "sensualist." Indeed, for this criticism, only themes that concern the sensations (in the narrow sense of the word) are truly worthy of attention. Here is how Georges Poulet describes this requirement, in his preface to Richard's first book of thematic criticism, *Littérature et Sensation* (the title itself is significant):

Somewhere in the depths of consciousness, on the other side

of the region where everything has *become* thought, at a point opposite the point of access, there has been and therefore still is light, objects, and even eyes to see them. Criticism cannot be content to think a thought. It must work its way back, through this thought, from image to image to the sensations [my italics].

This passage contains a very distinct opposition between, let us say, the concrete and the abstract. On one side, we find objects, light, eyes, images, sensations, and on the other, thought, abstract concepts. The first term of the opposition seems to be given a double value: to begin with, it is first in time (cf. that "become"); secondly, it is the densest, the most important element and consequently it constitutes the privileged object of criticism.

In the preface to his next book, *Poésie et Profondeur*, Richard returns to precisely the same notion. He describes his trajectory as an attempt

to rediscover and describe the fundamental intention, the project which dominates their endeavor. I have sought to grasp this project at its most elementary level, the level where it is asserted with most humility but also with most honesty: the level of pure sensation, of the raw emotion or the dawning image. . . . I have considered the idea less important than the obsession, I have regarded theory as secondary in comparison with the dream.

Gérard Genette has properly described this point of departure as the "sensualist postulate, according to which the fundamental, and hence the authentic, coincides with the sensuous experience" (*Figures*).

We have already had occasion (in speaking of Northrop Frye) to express our divergence from this postulate. And we follow Genette further, when he writes:

The postulate, or the prejudice, of structuralism is virtually the converse of that of Bachelardian analysis: structuralism holds that certain elementary functions of even the most archaic thought

already participate in a superior abstraction, that the schemas and operations of the intellect are perhaps "deeper," closer to the source than the reveries of the sensuous imagination, and that there exists a logic, even a mathematics, of the unconscious.

We have here, then, an opposition between two schools of thought which, in fact, extend beyond the limits of structuralism and Bachelardian analysis: on one side we find Lévi-Strauss as well as Freud or Marx, on the other Bachelard as well as thematic criticism, Jung along with Frye.

We might say, as we did apropos of Frye, that the postulates are not discussed, that they result from an arbitrary choice; but it will be useful, once again, to consider their consequences. Let us leave aside the implications concerning "primitive mentality" and concern ourselves only with what touches upon literary analysis. The refusal to grant importance to abstraction in the world he describes leads Richard to underestimate the need for abstraction in the critical task. The categories he uses to describe the sensations of the poets he studies are as concrete as those sensations themselves. For evidence, we need merely glance at what in French are appropriately called the *tables de matière* of his books. Here are some examples: "Diabolic Depth — Cave — Volcano"; "Sun — Stone — Brick — Slate — Verdure — Foliage"; "Butterflies and Birds — Fluttering Scarf — Baked Earth — Dust — Silt — Sun," etc. (these occur in connection with the chapter on Nerval in *Poésie et Profondeur*). Or again, still apropos of Nerval:

> In his dreams he conceives of Being, for example, as a lost, buried fire: hence he seeks out the spectacle of rising suns and also of bricks gleaming in the sunset, the contact of the fiery hair of young women or the animal warmth of their flesh, *bionda e grassotta*.

The themes described are those of sun, brick, hair; the term which describes them is that of lost fire.

There is a great deal to be said about this critical language. We do not contest its pertinence: specialists in each particular author whose work is discussed in this way must say to what degree these observations are correct. It is on the level of the analysis itself that such a language is subject to criticism. Terms so concrete obviously form no logical system (as thematic criticism would be the first to concede); but if the list of terms is infinite and uncoordinated, in what way is it preferable to the text itself which, after all, contains all these sensations and organizes them in a certain manner? At this stage, thematic criticism seems to be no more than a paraphrase (certainly an inspired paraphrase, in Richard's case); but paraphrase is not analysis. In Bachelard or Frye, we have a system, even if it remains on the level of the concrete: that of the four elements, or the four seasons, etc. With thematic criticism, we have an infinite list of terms which must be invented from zero for each text.

From this point of view, there are two types of criticism — let us call one narrative, the other logical. Narrative criticism follows a horizontal line, it proceeds from theme to theme, stopping at a more or less arbitrary moment; each of these themes is as non-abstract as the next, they constitute an endless chain, and the critic — here similar to the narrator — chooses almost at random the beginning and the end of his narrative (just as, say, a character's birth and death are, finally, only moments chosen arbitrarily for the beginning and the end of a novel). Genette quotes a sentence from Richard's *L'Univers Imaginaire de Mallarmé* in which this attitude is crystallized: "The carafe is therefore no longer an azure, and not yet a lamp." Azure, carafe and lamp form a homogeneous series across which the critic slides, always at the same depth. The typical structure of books of thematic criticism illustrates this narrative and horizontal attitude: they are generally collections of essays, each of which constitutes the portrait of a different writer. To deal with a more general level is, so to speak, impossible: theory is not permitted an entrance visa here.

The logical attitude, on the other hand, follows a vertical line. The carafe and the lamp may constitute a first level of generality — but then it will be necessary to rise to another, more abstract level. The figure formed by the trajectory is that of a pyramid rather than that of a surface line. Thematic criticism, on the contrary, is reluctant to leave the horizontal. But thereby it relinquishes any analytic and, even more, any explanatory claim.

We sometimes find, it is true, certain theoretical preoccupations in the texts of thematic criticism, especially in the work of Georges Poulet. But in avoiding the danger of sensualism, this criticism contradicts another of our initial postulates: that of regarding the literary work not as the translation of a pre-existing thought, but as the site where a meaning appears that cannot exist elsewhere. To suppose that literature is only the expression of certain thoughts or experiences of the author is to condemn literary specificity from the start — is to grant literature a secondary role, that of one medium among others. Yet this is the only way that thematic criticism conceives of the function of abstraction in literature. Here are some characteristic assertions by Richard: "We like to see it [literature] as an *expression* of choices, obsessions, and problems located at the heart of personal existence" (*Littérature et Sensation*). "It seems to me that literature is one of the places where this effort of consciousness to apprehend Being is *betrayed* with most simplicity or even naiveté" (*Poésie et Profondeur*, my italics). *Expression* or *betrayal* — literature is here never anything but a means of translating certain problems which subsist outside of it, independent of it: a notion we cannot easily accept.

This brief analysis shows that thematic criticism, by its anti-universal definition, does not afford the means to analyze and explain the general structures of literary discourse (we shall indicate below the level on which this method does seem pertinent). Thus we are still as unequipped with a method for the analysis of themes as we were before. However, two dangers have appeared which we must try to avoid: the refusal

to leave the field of the concrete, to recognize the existence of abstract rules; and the utilization of non-literary categories to describe literary themes.

Now, armed with this very light theoretical panoply, let us turn to the critical texts that deal with the fantastic. We shall discover in them a surprising unanimity of method.

Herewith, some examples of classification of themes. Dorothy Scarborough, in one of the first books concerned with this question, *The Supernatural in Modern English Fiction*, proposes the following classification: modern ghosts; the devil and his allies; supernatural life. Penzoldt affords a more detailed division (in his chapter entitled "The Leading Motif"): ghosts, phantoms, vampires, werewolves, witches and witchcraft, invisible beings, the animal spectres. (As a matter of fact, this division is based on another, much more general one to which we shall return in Chapter 9.) Vax proposes a very similar list: werewolves; vampires; parts of the human body; the pathology of personality; the interplay of invisible and visible; the alterations of causality, space and time; regression. There is a curious shift here from images to their causes: the theme of the vampire can obviously be a consequence of the pathology of personality. The list is thus less coherent than the preceding ones, even if more suggestive.

Caillois, in *Images, Images . . .* , offers an even more detailed classification. His thematic classes are the following: the pact with the devil (e.g., *Faust*); the anguished soul that requires, in order to achieve peace, that a certain action be performed; the spectre doomed to an incoherent and endless journey (e.g., *Melmoth*); death personified appearing among the living (e.g., "The Masque of the Red Death"); the indefinable, invisible "thing" that haunts (e.g., "Le Horla"); vampires, i.e., the dead who obtain perpetual youth by sucking the blood of the living (many examples); the statue, figure, suit of armor, or automaton that suddenly comes to life and

acquires a deadly independence (e.g., "La Vénus d'Ille"); the magician's curse involving a dreadful and supernatural disease (e.g.,"The Mark of the Beast"); the phantom-woman, appearing from the beyond, seductive and deadly (e.g., *Le Diable Amoureux*); the inversion of the realms of dream and reality; the room, apartment, house, or street erased from space; the cessation or repetition of time (e.g., *The Saragossa Manuscript*).

The list, as we see, is copious. At the same time, Caillois insists on the systematic, closed character of the themes of the fantastic:

> I have perhaps gone too far in asserting that it was possible to classify these themes which nonetheless depend quite closely on a given situation. However, I still believe that they can be enumerated and deduced, so that we might even conjecture those that are missing from the series, as Mendeleev's cyclical classification permits us to calculate the atomic weight of elements not yet discovered or unknown to nature but which exist in virtuality.

One can only agree with such an aspiration. But one may search Caillois' writings in vain for the logical rule that would permit such a classification to be made; and I do not think that its absence is accidental. All the classifications hitherto enumerated contravene our first rule: to classify not concrete images but abstract categories (with the insignificant exception of Vax). At the level on which Caillois describes them, these "themes" are, on the contrary, limitless, and they do not obey rigorous laws. We might reformulate this objection as follows: underlying the classifications, we find the notion of an invariable meaning for each element of the work, independent of the structure in which it will be integrated. To classify all vampires together, for instance, implies that the vampire always signifies the same thing, whatever the context in which it appears. Now, starting as we do from the notion that the work forms a coherent whole,

a structure, we must grant that the meaning of each element (here, each theme) cannot be articulated outside of its relations with the other elements. What is being proposed here are labels, appearances, not true thematic elements.

A recent article by Witold Ostrowsky goes further than these enumerations by attempting to formulate a theory. His study, moreover, is significantly entitled: *The Fantastic and the Realistic in Literature: Suggestions on How to Define and Analyze Fantastic Fiction.* According to Ostrowsky, we may represent human experience by the following schema:

$$
\left.\begin{array}{c} characters \\ 1 \qquad 2 \\ (\text{matter} + \text{consciousness}) \\[4pt] world\ of\ objects \\ 3 \qquad 4 \\ (\text{matter} + \text{space}) \end{array}\right\}
\begin{array}{c} 5 \\ in\ action \\ controlled\ by \end{array}
\left\{\begin{array}{c} 6 \\ causality \\ 7 \\ and/or \\ goals \end{array}\right\}
\begin{array}{c} 8 \\ in\ time \end{array}
$$

The themes of the fantastic are defined as being, in each case, the transgression of one or more of the eight elements constituting this schema.

Here we have an attempt at systematization on an abstract level, no longer a catalogue on the level of images. Yet it is difficult to accept such a schema because of the evident *a priori* (and moreover non-literary) character of the categories that are supposed to describe literary texts.

In short, all these analyses of the fantastic are as lacking in concrete suggestions as was thematic criticism in indications of a general order. Hitherto critics (with the exception of Penzoldt) have been content to draw up lists of supernatural elements without managing to indicate their organization.

As if all these problems we encounter on the threshold of a semantic study were not enough, there are others, inherent

in the very nature of the literature of the fantastic. Let us recall the *données* of the problem: in the universe evoked by the text, an event — an action — occurs which proceeds from the supernatural (or from the pseudo-supernatural); this action then provokes a reaction in the implicit reader (and generally in the hero of the story). It is this reaction which we describe as "hesitation," and the texts which generate it, as fantastic. When we raise the question of themes, we put the "fantastic" reaction in parentheses, in order to be concerned solely with the nature of the events that provoke it. In other words, from this viewpoint, the distinction between the fantastic and the marvelous is no longer of interest, and we shall be concerned with works belonging to one genre or the other without differentiation. Nonetheless the text may emphasize the fantastic (i.e., the reaction) so strongly that we can no longer distinguish the supernatural which has provoked it: the reaction makes it impossible to grasp the action, instead of leading us back to it. Putting the fantastic in parentheses then becomes extremely difficult, if not impossible.

In other words: concerned as we are here with the perception of an object, we may insist as much upon the perception as upon the object. But if the insistence on the perception is too strong, we no longer perceive the object itself.

There are very diverse examples of this impossibility of reaching the theme. Let us first consider Hoffmann, whose *oeuvre* constitutes a virtual repertory of fantastic themes. What seems to matter to him is not what one is dreaming about, but the fact that one is dreaming and the joy that the dreaming provokes. The admiration to which he is provoked by the existence of the supernatural world often prevents us from seeing what this world consists of. The emphasis has shifted from the utterance to the act of uttering. The conclusion of "The Golden Pot" is revealing in this regard. After recounting the marvelous adventures of the student Anselm, the narrator himself appears and declares:

But then I felt a sudden twinge and transport of pain. Ah happy Anselm, who has cast away the burden of ordinary life, who in the love of gentle Serpentina soars to Atlantis — While I, poor I, must soon, nay, at any moment, leave even this fair hall — which itself is far from an estate in Atlantis — and again be transplanted to my garret, where ensnared among the trifles of necessitous existence, my heart and my sight are so bedimmed with a thousand wiles, as with thick fog, that the fair Lily will never, never be beheld by me! At this moment the archivist Lindhorst patted me gently on the shoulder and said: "Soft, soft, my honored friend! Do not lament! Were you not even in Atlantis? And have you not at least cultivated a pretty little estate of lovely words there, the poetical possession of your inner self? And is Anselm's felicity anything more than living in Poetry? Can anything but Poetry reveal itself as the sacred Harmony of all Beings, as the deepest secret of Nature?"

This remarkable passage puts an equals sign between supernatural events and the possibility of describing them; between the purport of the supernatural and its perception. The happiness Anselm discovers is identical with that of the narrator who has been able to imagine it, who has been able to write his story. And because of this delight in the existence of the supernatural, it is all the more difficult to know it.

We find the converse situation in Maupassant, but with similar effects. Here the supernatural provokes such anxiety, such horror, that we scarcely manage to distinguish what constitutes it. "Qui Sait?" is perhaps the best example of this method: the supernatural event which constitutes the tale's point of departure is the sudden and strange animation of the furniture in a house. There is no logic in the behavior of the furniture, and this phenomenon makes us wonder "what it means" less than it amazes us by the strangeness of the fact itself. It is not the animation of the furniture which counts so much, but the fact that someone could imagine such a thing and even experience it. Again the perception of the super-

natural casts a heavy shadow over the supernatural itself and makes its access difficult to us.

Henry James's "Turn of the Screw" offers a third variant of this singular phenomenon, in which perception constitutes a screen rather than removes one. As in the preceding texts, our attention is so powerfully concentrated on the act of perception that we never know the nature of what is perceived (what are the vices of the discharged tutor and governess?). Anxiety predominates here, but it assumes a much more ambiguous character than in Maupassant.

After these scruples on the threshold of a study of fantastic themes, we possess only a few negative certitudes. We know what we must not do, not how to proceed. Consequently, we shall adopt a prudent position: we shall confine ourselves to the application of an elementary technique, without presuming on the method to follow in general.

We shall first of all group the themes in a purely formal, or more precisely distributional, fashion, by studying their *compatibilities* and *incompatibilities*. We shall thus obtain several groups of themes. Each group will combine those which can appear together and those which actually are together in individual works. Once these formal classes have been obtained, we shall try to interpret the classification itself. Our task will therefore have two stages, which roughly correspond to the two tenses of description and explanation.

This procedure, innocent as it may appear, is not entirely so. It implies two hypotheses which are far from being proved: first, that semantic classes correspond to formal classes, i.e., that different themes necessarily have a different distribution; second, that a work possesses such a degree of coherence that the laws of compatibility and incompatibility can never be infringed within it. Which is far from being certain, if only because of the numerous borrowings that characterize any literary work. A folklore tale, for example, being less

homogeneous, will often involve elements that never appear together in literary texts. We must therefore be guided by an intuition which it is difficult to make explicit for the time being.

7

themes of the self

We shall begin, then, with a first group of themes united by a purely formal criterion: their co-presence. Let us recall, first of all, a story from the *Arabian Nights*, the "Second Calender's Tale." It begins as a realistic tale. The hero, who is the king's son, completes his education in his father's house and sets out to visit the Sultan of the Indies. On the way, his party is attacked by thieves and he barely escapes with his life. He finds himself in an unknown city, without means and without the possibility of making himself known. Following the advice of a tailor, he begins cutting wood in the nearby forest and selling it in the city to earn his livelihood. Up to this point, as we see, no supernatural element intervenes.

But one day an incredible event occurs. Pulling up a tree root, the prince discovers an iron ring attached to a trap door; he raises the door, descends the staircase which appears beneath it, and finds himself in an elaborately decorated underground palace. A lady of extraordinary beauty welcomes him and informs him that she is a king's daughter, and that she had been carried off by a wicked genie, who hid her in this palace and comes to sleep with her every tenth day (for

his legitimate wife is very jealous). The princess, moreover, can summon the genie at any moment, merely by touching a certain talisman. She invites the prince to remain with her nine days out of ten, and offers him a bath, an exquisite repast, and her bed for the night. But the following day she is foolish enough to offer him some wine. Once he is drunk, the prince determines to provoke the genie and breaks the talisman.

The genie appears, and in the course of doing so, causes so much noise that the prince flees, terrified, leaving the helpless princess in the genie's hands and a few pieces of his clothing scattered about the room. This last piece of carelessness will be his ruin. The genie, taking the form of an old man, comes to the city and discovers the owner of the clothes; he carries the prince up into the sky, then down into the cave, in order to wring a confession of his crimes from him. But neither the prince nor the princess confesses, which does not keep the genie from punishing them. He cuts off the princess' arm, and she dies from the wound; as for the prince, despite the story he manages to tell — according to which one must never take revenge on those who have injured you — he is turned into a monkey.

This situation will be the source of a new series of adventures. The intelligent monkey is rescued by a ship whose captain is charmed by the creature's manners. One day, the ship reaches harbor in a kingdom whose grand vizir has just died. The sultan of this kingdom asks every newcomer to send him a sample of his handwriting, in order to choose, by this criterion, the vizir's successor. Of course, it is the monkey's writing that turns out to be the finest. The sultan invites the monkey to his palace, where the creature writes verses in his honor. The sultan's daughter comes to see the miracle; but since she has taken lessons in magic in her youth, she immediately divines that the monkey is a man transformed. She summons the genie, and the two of them wage a bitter combat, each transforming himself into a series of animals; in the end, they hurl flames at each other. The sultan's daughter

triumphs, but dies soon after, having had just time enough to restore the prince to human form. Saddened by the disasters he has provoked, the prince becomes a calender or dervish, and it is the accidents of his journey which have led him to the very house where he is now telling this same tale.

In the face of this apparent thematic variety, we are at first perplexed. How to describe it? Yet, if we isolate the supernatural elements, we shall see that it is possible to divide them into two groups. The first is that of *metamorphosis*. We have seen a man turned into a monkey and a monkey into a man. The genie turns himself, at the beginning, into an old man. During the scene of the duel, metamorphoses follow one upon another: the genie first becomes a lion, but the princess cuts him in two with a sword, and the lion's head turns into a huge scorpion. "Therewith the princess became a serpent, and engaged in bitter combat with the scorpion, which not having the advantage, took the form of an eagle and flew off. But the serpent then became a still more powerful eagle, and gave pursuit." Soon after, a black and white cat appears, pursued by a black wolf. The cat turns into a worm and makes its way into a pomegranate, which swells to the size of a pumpkin; the pomegranate explodes; the wolf, now transformed into a cock, begins swallowing the pomegranate seeds. One escapes and falls into the water, where it becomes a little fish. At the end, both characters reacquire their human form.

The other group of fantastic elements is based on the very existence of supernatural beings, such as the genie and the princess-sorceress, and on their power over human destiny. Both are capable of transforming themselves and others, and both can fly or transport beings and objects in space, etc. This is one of the constants of the literature of the fantastic: the existence of beings more powerful than men. Yet, it is not enough to acknowledge this fact, we must further seek its significance. We can say, of course, that such beings symbolize dreams of power; but we can go no further. Indeed,

in a general fashion, supernatural beings compensate for a deficient causality. Let us say that in everyday life there are some events which are explained by known causes, and others that appear to be due to chance. In this latter case, there is not, indeed, an absence of causality, but the intervention of an isolated causality which is not directly linked to other causal series controlling our life. If, however, instead of accepting the intervention of chance, we postulate a generalized causality, a necessary relation of all the facts among themselves, we must admit the intervention of supernatural forces or beings hitherto unknown to us. Thus the fairy who assures a character's fortunate destiny is merely the incarnation of an *imaginary causality* for what might just as well be called chance, fortune, accident. The wicked genie who interrupts the amorous frolic in the calender's tale is none other than the hero's bad luck. But the words *luck* or *chance* are excluded from this part of the fantastic universe. We read in "L'Esquisse Mystérieuse," one of Erckmann-Chatrian's fantastic tales: "After all, what is chance if not the effect of a cause that escapes us?" We might speak here of a generalized determinism, a *pan-determinism*: everything, down to the encounter of various causal series (or "chance") must have its cause, in the full sense of the word, even if this cause can only be of a supernatural order.

By interpreting the world of genies and fairies in this way, a curious resemblance becomes apparent between these fantastic and after all traditional images and the much more "original" imagery we find in the works of writers like Nerval or Gautier. There is no break between the one and the other, and the fantastic as we find it in Nerval helps us to understand the fantastic as we find it in the *Arabian Nights*. Hence we cannot agree with Hubert Juin, who, in his preface to Nerval's fantastic tales, opposes the two tonalities: "Others see phantoms, vampires, ghouls, in short everything which proceeds from gastric disturbance and which is the wrong fantastic. Nerval alone sees . . . what the dream is."

Here are several examples of Nerval's pan-determinism. One day, two events occur simultaneously: Aurélia has just died; and narrator, ignorant of the fact, thinks of a ring he once gave her; the ring was too large, he had had it cut down. "I realized my mistake only upon hearing the sound of the saw. I seemed to see blood flowing. . . ." Chance? Coincidence? Not for the narrator of *Aurélia*.

Another day, he goes into a church. "I was about to kneel in the last rows of the choir, and I slid from my finger a silver ring whose bevel bore these three Arabic words: *Allah! Mohammed! Ali!* Immediately several candles flamed up in the choir. . . ." What for others would be no more than a coincidence in time is here a cause.

Once more, he is walking in the street on a stormy day:

> The flood was rising in the nearby streets; I ran down the Rue Saint-Victor, and with the notion of stopping what I supposed to be the universal inundation, I threw the ring I had bought at Saint-Eustache into the deepest part. At the same moment, the storm subsided, and a sunbeam began to shine through the clouds.

The ring here provokes the atmospheric change. We notice at the same time the prudence with which this pan-determinism is presented: Nerval makes explicit only the temporal coincidence, not the causality.

A final example is drawn from a dream:

> We were in the countryside under a starry sky which we had paused to contemplate, and the spirit stretched its hand over my forehead, as I had done the night before, attempting to magnetize my companion; immediately one of the stars I was gazing at in the sky began to grow larger. . . .

Nerval is quite aware of the significance of such narratives. Apropos of one of them, he remarks: "Doubtless I

shall be told that chance might have brought it about that at such a moment a suffering woman might have cried out in the environs of my residence. — But, to my mind, the earthly events were linked to those of the invisible world." And again:

> The hour of our birth, the point of the earth where we appear, the first gesture, the name of the room — and all those consecrations, and all those rites imposed upon us — all this establishes a fortunate or fatal series on which the entire future depends: . . . It has been said, and truly: nothing is neutral, nothing is impotent in the universe; an atom may ruin all, an atom may ransom all!

Or once again, in a laconic formulation: "Everything corresponds to everything else."

Let us note here — and return to it at greater length below — the resemblance of this conviction, which Nerval derives from madness, to the kind afforded by certain drugs. I quote here from Alan Watts' book *The Joyous Cosmology*; "For in this world nothing is wrong, nothing is even stupid. The sense of wrong is simply failure to see where something fits into a pattern, to be confused as to the hierarchical level upon which an event belongs." Here again, "everything corresponds to everything else."

Pan-determinism has as a natural consequence what we may call "pan-signification": since relations exist on all levels, among all elements of the world, this world becomes highly significant. As we have already seen with Nerval: the hour at which one is born, the name of the room, everything is charged with meaning. Even more: beyond the primary, obvious meaning, one can always discover a deeper meaning (a super-interpretation). Thus the speaker in *Aurélia*, in the asylum: "I attributed a mystical meaning to the conversations of the guards and to those of my companions." And Gautier during a hashish experiment:

A veil was sundered in my mind, and it became clear to me
that the members of the club were none other than cabbalists.
. . . The figures of the paintings . . . stirred in painful contortions,
like deaf-mutes trying to give important advice on some supreme
occasion. It was as if they were trying to warn me of some dan-
ger to avoid.

In this world, every object, every being means something.

Let us move on to still higher level of abstraction: what
is the ultimate meaning of the pan-determinism manipulated
by fantastic literature? Of course it is not necessary to verge
on madness, like Nerval, or to take drugs, like Gautier, in
order to believe in pan-determinism: we have all experienced
it — but without giving it the extension it has here. The rela-
tions that we establish among objects remain purely mental
and in no way affect the objects themselves. In Nerval or
Gautier, on the contrary, these relations extend to the physical
world: we touch a ring and candles flare up, we throw the
ring and a flood recedes. In other words, on the most abstract
level, pan-determinism signifies that the limit between the
physical and the mental, between matter and spirit, between
word and thing, ceases to be impervious.

Now let us return, bearing this conclusion in mind, to
the metamorphoses we have left somewhat high and dry. On
our present level of generality, they are subject to the same
law of which they form particular cases. We say readily enough
that someone monkeys around, or that he fights like a lion,
like an eagle, etc. The supernatural begins the moment we
shift from words to the things these words are supposed to
designate. The metamorphoses too, therefore, constitute a
transgression of the separation between matter and mind as
it is generally conceived. It should be observed also that there
is no break between the apparently conventional imagery of
the *Arabian Nights* and the more "personal" imagery of the
nineteenth-century writers. Gautier establishes the link by
describing his own transformation into stone in this fashion:
"Indeed, I felt my limbs becoming petrified, and the marble

enveloping me to the thighs, like the Daphne in the Tuileries;
I was a statue to the mid-body, like those enchanted princes
of the *Arabian Nights*." In the same tale, the narrator receives
an elephant head. Later, we witness the metamorphosis of
the mandragora-man: "This seemed to vex the mandragora-
man greatly, for he shrank, flattened, faded, and uttered inar-
ticulate groans; finally he lost all human appearance, and rolled
across the floor in the form of a forked salsify."

In *Aurélia*, we note similar metamorphoses. Here a lady
"gracefully embraced a long stem of hollyhock with her bare
arm, then began to grow under a bright sunbeam, so that
gradually the garden assumed her form, and the flowerbeds
and trees became the knots and garlands of her clothing."
Elsewhere, monsters join combat to cast off their strange forms
in order to become men and women. "Others assumed, in
their transformations, the countenance of wild beasts, of fish
and of birds."

One might say that the common denominator of the two
themes, metamorphosis and pan-determinism, is the collapse
(which is also to say the illumination) of the limit between
matter and mind. Thus we may advance a hypothesis as to
a generating principle of all the themes collected in this first
system: *the transition from mind to matter has become
possible*.

We can find pages, in the texts we are considering, where
this principle is directly stated. Nerval writes: "From where
I was, I descended, following my guide, into one of those
high structures whose clustered roofs presented this strange
aspect: it seemed to me that my feet sank into successive
layers of the edifices of different ages." The mental transition
from one age to the next here becomes a physical one. Words
are identified with things. Similarly in Gautier: someone has
uttered the sentence, "Today we'll have to die laughing!"
The remark virtually becomes a palpable reality: "The joyous
frenzy was at its zenith; nothing could be heard but convulsive
gasps, inarticulate gurgles. Laughter had lost its habitual

timbre and was transformed into groans; spasms succeeded pleasure; Daucus-Carota's remark was about to come true."

Between idea and perception, the transition is easy enough. The narrator of *Aurélia* hears these words: *Our past and our future are one. We live in our race and our race lives in us.* "This *idea* immediately became *visible* to me, and as if the walls of the room had opened onto infinite prospects, I seemed to see an uninterrupted chain of men and women in whom I existed and who existed within me" (italics mine). The idea becomes a matter of perception. Here is a converse example, where sensation is transformed into idea: "Those countless stairways you exhausted yourself climbing up and down were the very links of your old illusions which encumbered your thought. . . . "

It is curious to note here that such a collapse of the limits between matter and mind was considered, especially in the nineteenth century, as the first characteristic of madness. Psychiatrists generally posited that the "normal man" possessed several contexts of reference and attached each fact to only one among them. The psychotic, on the contrary, was incapable of distinguishing these different contexts and confused the perceived with the imaginary:

> It is well known that the schizophrenic's aptitude to separate the realms of reality and the imagination is weakened. Contrary to so-called normal thought, which must remain within the same realm, or frame of reference, or universe of discourse, the thought of the schizophrenic obeys no requirements of a single reference [Angyal].

The same collapse of limits is central to the drug experience. Watts wrote at the very beginning of his account: "The greatest superstition of all consists in the separation of body and mind." We find the same feature, oddly enough, in infants. According to Piaget, "at the beginning of his development, the infant does not distinguish the psychic world from the

physical one." This way of describing the world of infancy of course remains captive of an adult vision, in which precisely those two worlds are distinguished: we are working with an adult simulacrum of infancy. But this is in fact what happens in the literature of the fantastic: the limit between matter and mind is not unknown here, as it is in mythical thought, for instance; it remains present, in order to furnish the pretext for incessant transgressions. Gautier writes: "I no longer felt my body; the bonds of matter and mind were loosened."

This law, which we find at the source of all the distortions contributed by the fantastic within our system of themes, has some immediate consequences. Thus, we can here generalize the phenomenon of metamorphoses and say that a character will readily be multiplied. We all experience ourselves *as if* we were several persons — here the impression will be incarnated on the level of *physical* reality. The goddess addresses the narrator of *Aurélia*: "I am the same as Mary, the same as your mother, the same woman you have always loved." Elsewhere, Nerval writes: "A terrible idea occurred to me: 'Man is double,' I told myself. 'I am a double man,' wrote one Church Father. . . . In every man, there is a spectator and an actor, the man who speaks and the man who answers." The multiplication of personality, taken literally, is an immediate consequence of the possible transition between matter and mind: we are several persons mentally, we become so physically.

Another consequence of the same principle has still greater extension: this is the effacement of the limit between subject and object. The rational schema represents the human being as a subject entering into relations with other persons or with things that remain external to him, and which have the status of objects. The literature of the fantastic disturbs this abrupt separation. We hear music, but there is no longer an instrument external to the hearer and producing sounds, on the one hand, and on the other the listener himself. Gautier writes: "The notes vibrated so powerfully that they entered my breast like

gleaming arrows; soon the melody seemed to emerge from my own being. . . . Weber's soul had been incarnated in myself." Similarly in Nerval: "Lying on a camp bed, I heard the soldiers speaking of an unknown man arrested like myself, and whose voice had echoed in the same room. By a singular effect of vibration, it seemed to me that this voice resounded in my own breast."

We look at an object — but there is no longer any frontier between the object, with its shapes and colors, and the observer. Again Gautier: "By a strange miracle, after a few moments' contemplation, I dissolved into the object I gazed at, and I myself became that object."

For two people to understand one another, it is no longer necessary that they speak: each can become the other and know what the other is thinking. The narrator of *Aurélia* has precisely this experience when he encounters his uncle. "He made me sit beside him, and a kind of communication was established between us; for I cannot say I heard his voice; only, as my thoughts turned to some subject, the explanation of it immediately became clear to me." Or again; "Without asking anything of my guide, I understood by intuition that these heights and at the same time these depths were the retreat of the original inhabitants of the mountain." Since the subject is no longer separated from the object, communication is made directly, and the whole world participates in a system of generalized communication. Here is how this conviction is expressed in Nerval:

> This thought led me to the notion that there was a huge conspiracy of all living beings to restore the world to its primordial harmony, and that communications took place by the magnetism of the stars; that an unbroken chain linked minds all over the world dedicated to this general communication, and the songs, dances, glances, increasingly magnetized, expressed the same aspiration.

We may note once again the proximity of this thematic constant of the literature of the fantastic with one of the basic

characteristics of the world of the child (or, more exactly, as we have seen, with its adult simulacrum). Piaget writes: "Early in mental development, there exists no precise differentiation between the self and the external world." Similarly, according to Watts, for the world of drugs: "The organism and the surrounding world form a unique and integral scheme of action, in which there is no subject and no object, no agent and no patient." Or again: "I begin to feel that the world is at once inside and outside my head. . . . I do not look at the world, I do not confront it; I know it by a continuous process which transforms it into myself." The same is true, finally, of psychotics. Goldstein writes: "The psychotic does not consider the object as part of an organized external world, distinct from himself, as the normal person does. . . . The normal barriers between the self and the world vanish, and in their place we find a kind of cosmic fusion." We shall attempt to interpret these similarities later on.

The physical world and the spiritual world interpenetrate; their fundamental categories are modified as a result. The time and space of the supernatural world, as they are described in this group of fantastic texts, are not the time and space of everyday life. Here time seems suspended, it extends beyond what one imagines to be possible. Thus for the narrator of *Aurélia*: "This was the signal for a complete revolution among the spirits which were unwilling to acknowledge the new possessors of the world. I do not know how many thousands of years these battles lasted, combats which drenched the globe in blood." Time is also one of the chief themes of Gautier's "Hashish Club." The narrator is hurrying, but his movements are incredibly slow: "I stood up with great difficulty and made for the door of the salon, which I reached only after a considerable interval, some unknown power forcing me to retreat one step for every three I took. By my calculations, I took ten years to cover this distance." He then descends a staircase; but the steps seem interminable: "I shall reach the bottom the day after judgment day," he

tells himself, and when he does reach it: "This maneuver
lasted a thousand years, by my count." He must arrive at
eleven, but he is told, at a given moment: "You will never
get there by eleven; it is fifteen hundred years since you set
out." The ninth chapter of the tale describes the burial of
time. It is entitled: "Do Not Believe Chronometers." The
narrator is told: " 'Time is dead; henceforth there will be no
more years, nor months, nor hours; Time is dead and we
are walking in its funeral procession. . . .' 'Good God!' I
exclaimed, struck by a sudden idea, 'if there is no more time,
when could it be eleven? . . .' " Once again, the same
metamorphosis occurs in the drug experience, during which
time seems "suspended," and in the experience of the psychot-
ic, who lives in an eternal present without the notion of past
or future.

Space is transformed in the same way, as in the following
examples taken again from Gautier's "Hashish Club" — the
description first of a stairway and then of an inner courtyard:

> The two ends, engulfed in shadows, seemed to plunge into
> heaven and hell, into two abysses: looking up, I vaguely per-
> ceived, in a vast perspective, the superposition of countless
> landings, flights to be climbed as though to reach the top of the
> Tower of Lylacq; looking down, I glimpsed depths of stairs,
> whirling spirals, dazzling circumvolutions The courtyard
> had assumed the proportions of the Champ-de-Mars, and in a
> few hours had been bordered with giant structures which raised
> against the horizon a fretwork of towers, obelisks, domes,
> gables, pyramids worthy of Rome and Babylon.

We shall not try to describe any particular work, nor
even a theme exhaustively here, since the treatment of space
in the works of Nerval alone would in and of itself require
a very extensive study. Our endeavor is to indicate the princi-
pal characteristics of the world in which the supernatural
events appear.

Let us sum up: the principle we have discovered may be designated as the fragility of the limit between matter and mind. This principle engenders several fundamental themes: a special causality, pan-determinism; multiplication of the personality; collapse of the limit between subject and object; and lastly, the transformation of time and space. This list is not exhaustive, but we may say that it collects the essential elements of the basic network of fantastic themes. We have given these themes, for reasons that will appear later, the label "themes of the self." It has been evident, in any case, throughout this analysis that there is a correspondence between the themes of the fantastic grouped here, and those categories we use to describe the world of the drug-user, the psychotic, or the infant. Hence a remark of Piaget's seems to apply word for word to our object: "Four fundamental processes characterize this intellectual revolution effected during the first two years of existence: these are the constructions of the categories of the object and of space, of causality and of time."

We may further characterize these themes by saying that they essentially concern the structuring of the relation between man and the world. We are, in Freudian terms, within the *perception-consciousness* system. This is a relatively static relation, insofar as it implies no particular actions, but rather a position — a perception of the world rather than an interaction with it. The term *perception* is important here: works that are linked to this thematic network constantly emphasize the problematic nature of this perception, and especially that of the fundamental sense, sight ("the five senses, which are merely one sense — the faculty of seeing," as Louis Lambert put it): to the point where we might designate all of these themes as "themes of vision."

This word — vision — will permit us to abandon certain over-abstract reflections and to return to the fantastic stories

we have just left. It will be easy to verify the relation between
the themes cited and vision in Hoffmann's "Princess Bram-
billa." The theme of this fantastic tale is the division of person-
ality, or doubling, and in a more general manner, the play
of dream and reality, mind and matter. Significantly, every
appearance of a supernatural element is accompanied by the
parallel introduction of an element belonging to the realm of
sight. It is, in particular, eyeglasses and mirrors that permit
penetration into the marvelous universe. Thus the charlatan
Celionati proclaims to the crowd, after having announced that
the Princess is present: " 'Would you even recognize the illus-
trious Princess Brambilla, if she passed before your eyes?
Indeed you could not, unless you made use of the eyeglasses
fabricated by the great Indian magician Ruffiamonte!...'
And the charlatan opened a box, from which he drew a pro-
digious quantity of huge eyeglasses. . . ." These glasses alone
afford access to the marvelous.

 A similar thing happens with the mirror, that object whose
relation with "marvel" on the one hand and on the other
with seeing (as in, to ad*mire*) Pierre Mabille has indicated
so accurately. (The mirror is present in Hoffmann's tale
whenever the characters must make a decisive step toward
the supernatural, and this relation is attested to in almost
all fantastic texts.)

> Suddenly the two lovers, Prince Cornelio Chiapperi and Princess
> Brambilla, roused from their deep lethargy and, discovering that
> they were on the rim of the pool, looked eagerly at themselves
> in these transparent waters. But no sooner had they seen each
> other in this mirror, than at last they recognized each other. . . .

Real wealth, true happiness (and these are found in the world
of the marvelous) are accessible only to those who manage
to see themselves in the mirror: "All those are rich and happy
who, like us, have been able to see and recognize themselves
— their life and their entire being — in the clear and magical

mirror of the springs of Urdar." Only by means of eyeglasses can Giglio recognize Princess Brambilla; and by means of the mirror, both can begin a life that is quite literally "marvelous."

"Reason," which rejects the marvelous, knows this very well, for it also renounces the mirror. "Many philosophers strictly forbid looking into the mirror of the waters, for in seeing the world and oneself upside down, one may be stricken with vertigo." And again:

> Many spectators who saw the whole natural world and their own images in this mirror, uttered cries of pain and rage as they stood up. They said it was contrary to reason, to the dignity of the human race, to the wisdom acquired by long and painful experience, to see the world and oneself thus reversed.

"Reason" declares itself against the mirror which offers not the world but an image of the world, matter dematerialized, in short, a contradiction of the law of non-contradiction.

Hence it would be more accurate to say that in Hoffmann it is not vision itself that is linked to the world of the marvelous, but rather eyeglasses and mirrors, those symbols of indirect, distorted, subverted vision. Giglio himself establishes the opposition between the two types of vision, as well as their relation with the marvelous. When Celionati declares that he is suffering from a "chronic dualism," Giglio rejects this expression as "allegorical," and defines his condition as follows: "I am suffering from an ophthalmia, from having worn eyeglasses too early." To see through eyeglasses brings the discovery of another world and distorts normal vision. The derangement is similar to that provoked by the mirror: "Something is wrong with my eyes, for generally I see everything reversed." Vision pure and simple reveals an ordinary world, without mysteries. Indirect vision is the only road to the marvelous. But is not this transcendence, this transgression, vision's very symbol and in a sense its highest praise? Eyeglasses and mirrors become the image of a vision that

is no longer the simple means of connecting the eye to a point in space, which is no longer purely functional, transparent, transitive, These objects are, in a sense, vision materialized or rendered opaque, a quintessence of sight. Moreover we find the same fruitful ambiguity in the word "visionary," which designates a person who both sees and does not see, and thus implies at once the higher degree and the negation of vision. This is why, seeking to exalt the eyes, Hoffmann needs to identify them with mirrors: "Her eyes [those of a powerful fairy] are the mirror in which all of love's madness is reflected, recognized, and joyously admired."

"Princess Brambilla" is not the only tale by Hoffmann in which vision is the predominant theme: we are literally beset, in his *oeuvre*, by microscopes, opera-glasses, false or real eyes, etc. Moreover, Hoffmann is not the only storyteller who permits us to establish the relation of our network of themes with vision. Yet we must be discreet in searching for such a parallelism: the mere appearance of the words "sight," "vision," "mirror," etc. in a text does not necessarily assure that we have found a variant of the "theme of vision." That would be to postulate for each minimal unit of literary discourse a unique and definitive meaning — which is precisely what we have refused to do.

In Hoffmann, at least, there is certainly a coincidence between the "theme of vision" (as it has surfaced in our descriptive lexicon) and the "images of sight," as we discover them in the text itself; whereby his work is particularly revealing.

We see too that it is possible to qualify this first network of themes in more than one way, according to the point of view one adopts. Before choosing among them or even clarifying them, we must examine a second thematic network.

8

themes of the other

Balzac's novel *Louis Lambert* represents one of the most extended explorations of what we have called the themes of the self. Louis Lambert is a being who incarnates, like the narrator of *Aurélia*, all the principles our analysis has revealed. Lambert lives in the world of ideas, but here ideas have become visible, sensuous; he explores the invisible the way others explore an unknown island.

An event occurs which we have never encountered in the texts of the thematic network just described. Louis Lambert decides to marry, having fallen in love not with a chimera, a memory, or a dream, but with a real woman; the world of physical pleasures begins to open to his senses, which had hitherto perceived only the invisible. Lambert himself scarcely dares believe it: "What! Our sentiments that had been so pure, our emotions that had been so deep, will take the delicious shapes of the thousand caresses I have dreamed of. Your tiny foot will slip out of its shoe for me, you will be all mine!" he writes to his fiancée. And the narrator summarizes this surprising metamorphosis in this way: "The letters which chance has preserved, moreover, clearly illustrate his transition from the pure idealism in which he had lived

to the most acute sensualism." The knowledge of the flesh will be added to that of the mind.

Suddenly the disaster occurs. The night before his wedding, Louis Lambert goes mad, falling into a cataleptic state, then into a profound melancholia whose direct cause seems to be his suspicion of his impotence. The doctors declare him incurable, and Lambert, shut up in a country house, dies after several years of silence, apathy, and moments of fugitive lucidity. Why this tragic development? The narrator, Lambert's friend, attempts several explanations. "The exaltation to which the expectation of the greatest physical pleasure must have brought him, further magnified in his case by chastity of the body and the soul's power, may have determined this crisis whose results are no better known than their cause." But beyond these psychical or physical causes is suggested a reason we might almost call a formal one: "Perhaps he saw in the pleasures of his marriage an obstacle to the perfection of his inner senses and to his flight through the worlds of the spirit." One must choose then, between satisfaction of the external and of the internal senses. Trying to satisfy them all leads to that scandal in the realm of form known as *madness*.

We might say further that the formal scandal attested to in the book corresponds to a strictly literary transgression: two incompatible themes are given side by side, in the same text. We can start from this incompatibility in order to establish the difference between two networks of themes: the first, which we know already under the name "themes of the self;" the second, where we happen to find sexuality, will be designated by "themes of the other." Gautier, moreover, has depicted the same incompatibility in his "Hashish Club":

> Nothing material mingled with this ecstasy; no earthly desire tainted its purity. Moreover love itself could not have magnified it — Romeo, had he but sampled hashish, would have forgotten

his Juliet. . . . I must agree that the loveliest girl of Verona, for a man who knows hashish, is not worth bothering about.

There exists, then, a theme that we shall never encounter in the works that produce the pure network of the themes of the self, but which recurs insistently in other fantastic texts. The presence or absence of this theme affords us a formal criterion for distinguishing, within the literature of the fantastic, two fields, each constituted by a considerable number of thematic elements.

Louis Lambert and "The Hashish Club," works that initially offer themes of the self, define from without — as though modeling around a hollow center — this new theme of *sexuality*. In examining specific works which belong to the second thematic complex, we may observe the ramifications of this theme. Here sexual desire may reach an unsuspected power: it is not a matter of one experience among others, but of what is most essential in life. Witness the priest Romuald in "La Morte Amoureuse":

> For having just once raised my eyes and looked upon a woman, for one apparently frivolous transgression, I have suffered the most wretched agitations these many years; my life has been darkened forever. [And again:] Never look at a woman, and walk always with your eyes fixed upon the ground, for however chaste and calm you may be, a moment suffices to make you lose eternity.

Here sexual desire gains an exceptional mastery over the hero. M.G. Lewis' *The Monk*, which preserves its interest chiefly on account of its descriptions of desire, offers perhaps the best examples of this mastery. The monk Ambrosio is first tempted by Matilda:

> As she uttered these last words, she lifted her arm, and made a motion as if to stab herself. The friar's eyes followed with dread

the course of the dagger. She had torn open her habit, and her bosom was half exposed. The weapon's point rested upon her left breast: and oh! that was such a breast! The moon-beams darting full upon it enabled the monk to observe its dazzling whiteness: his eye dwelt with insatiable avidity upon the beauteous orb: a sensation till then unknown filled his heart with a mixture of anxiety and delight; a raging fire shot through every limb; the blood boiled in his veins, and a thousand wild wishes bewildered his imagination. "Hold!" he cried, in an hurried, faltering voice; "I can resist no longer!"

Later on, Ambrosio's desire changes its object, but not its intensity. The scene during which the monk observes Antonia in a magic mirror while she prepares to take her bath is ample proof of this: once again, "his desires were worked up to frenzy." And again, during the frustrated rape of Antonia: "He remained for some moments devouring those charms with his eyes which soon were to be subjected to his ill-regulated passions. . . . His desires were raised to that frantic height by which brutes are agitated," etc. We are in the presence here of an experience incomparable, in its intensity, to any other.

It will not be surprising, then, to discover its relation to the supernatural: we know already that the supernatural always appears in an experience of limits, in "superlative" states. Desire, as a sensual temptation, finds its incarnation in several of the most common figures of the supernatural world, and most especially in the form of the devil. To simplify, one might say that *devil* is merely another word for *libido*. The seductive Matilda in *The Monk* is, we learn, a "secondary but cunning spirit" and a loyal servant of Lucifer. And in *Le Diable Amoureux*, we have an unambiguous example of the identity of devil and woman or, more exactly, of the devil and sexual desire. In Cazotte's tale, the devil does not try to seize Alvaro's eternal soul; rather — like a woman — he is content to possess his mortal body. The ambiguity of the reader's interpretation depends largely on the fact that Bion-

detta's behavior is in no way different from that of a woman in love. Consider this sentence: "According to a widespread rumor supported by numerous letters, a sprite carried off a captain of the guards in the service of the King of Naples and bore him to Venice." Does this not sound like the account of an ordinary event, in which the word "sprite," far from designating a supernatural being, seems to apply naturally enough to a woman? In his epilogue, Cazotte confirms the possibility: "The victim suffered what any man of feeling might suffer, seduced by the most likely appearances." There is no difference between an ordinary amorous adventure and Alvaro's adventure with the devil; the devil is woman *as* the object of desire.

The same is true in *The Saragossa Manuscript*. When Zibeddé attempts to seduce Alfonso, he seems to see horns sprouting on the forehead of his lovely cousin. Thibaud de la Jacquière believes he is about to possess Orlandina and become "the happiest of men"; but at the climax of his pleasure, Orlandina turns into Beelzebub. In another of the stories-within-the-story, we find this transparent symbol, the devil's sweetmeats, bonbons which provoke sexual desire and which the devil willingly bestows upon the hero.

Zorilla found my sweetmeat-box; she devoured two lozenges and offered others to her sister. Soon what I had thought I saw acquired a certain reality: the two sisters were overpowered by an inner emotion and abandoned themselves to it without realizing the fact. . . . Their mother came in. . . . Her glances, avoiding mine, fell upon the fatal sweetmeat-box; she took several lozenges from it and left. Soon she returned, caressed me again, called me her son, and clasped me in her arms. She left me reluctantly, and at the cost of a tremendous effort. The confusion of my senses rose to a passion: I felt the blood blowing in my veins like a fire, I scarcely saw the objects about me, and a cloud veiled my vision. . . . I walked out onto the balcony: the girls' door was ajar, and I could not keep from walking through it: the confusion of their senses was still more excessive than my own; it

alarmed me. Though I tried to wrest myself from their arms, I lacked the strength to do so. Their mother appeared; her reproach expired upon her lips: soon she lost the right to make it.

Moreover, once the "sweetmeat-box" is empty, the sensual transport is not interrupted — the devil's gift is the wakening of desire, which nothing can ever afterward bring to an end. The severe Abbé Serapion, in Gautier's "La Morte Amoureuse," will take this thematic organization still further. The courtesan Clarimonde, who makes pleasure her profession, is to him nothing but "Beelzebub in person." At the same time, the Abbé's own person illustrates the other term of the opposition: God, and even more, God's representatives on earth, the servants of religion. This, moreover, is the definition that Romuald gives of his new condition: "To be a priest! In other words, to be chaste, never to love, to distinguish neither sex nor age. . . ." And Clarimonde knows who her real adversary is: "Ah, how jealous I am of God, whom you have loved and love still, more than you do me!"

The ideal monk, as exemplified in Ambrosio at the beginning of Lewis' novel, is the incarnation of asexuality. "He is reported to be so strict an observer of chastity, that he knows not in what consists the difference of man and woman."

Alvaro, the hero of *Le Diable Amoureux*, lives in consciousness of the same opposition; and when he believes he has sinned by communicating with the devil, he decides to renounce women and become a monk: "Let us assume the ecclesiastical state. Fair sex, I must renounce you. . . ." To assert sensuality is to deny religion; this is why Vathek, the caliph who is concerned only with his pleasure, delights in sacrilege and blasphemy.

We find the same opposition in *The Saragossa Manuscript*. The object which keeps the two sisters from giving themselves to Alfonso is the locket he wears: "It is a trinket my mother gave me and which I promised to wear always; it contains a splinter of the True Cross." On the

day they receive him in their bed, Zibeddé first cuts the cord of the locket. The Cross is incompatible with sexual desire.

The description of the locket furnishes another element which belongs to the same opposition: the mother as contrary of the wife. For Alfonso's cousins to remove their chastity belts, the mother's gift of the locket must be removed as well. And in "La Morte Amoureuse" we find this curious sentence: "I had no more recollection of being a priest than of what I had done in my mother's womb." There is a kind of equivalence here between life in the body of the mother and the priestly condition, i.e., the refusal of woman as object of desire.

This equivalence occupies a central position in *Le Diable Amoureux*. The power that keeps Alvaro from wholly abandoning himself to Biondetta the devil-woman is precisely the image of his mother that appears at each decisive moment of the plot. Here is a dream of Alvaro's in which the opposition is made explicit:

> I thought I saw my mother in a dream. . . . As we were moving through a narrow pass in which I was carefully making my way, a hand suddenly pushed me over a precipice; I recognized it — Biondetta's hand. I fell, another hand pulled me back, and I found myself in my mother's arms.

The devil pushes Alvaro over the precipice of sensuality: his mother draws him back. But Alvaro yields more and more to Biondetta's charms, and his fall is imminent. One day, strolling through Venice and caught in a sudden shower, he takes refuge in a church; approaching one of the statues, he believes he recognizes his mother. Then he realizes that his dawning love for Biondetta is causing him to forget her, and he decides to leave the young woman and return to his mother: "Let us once again take shelter in this beloved asylum."

The devil-as-desire will seize Alvaro before he has taken refuge with his mother. Alvaro's downfall will be complete

— but not, however, definitive; just as if the matter were that of a simple amorous adventure, Doctor Quebracuernos shows him the road to salvation: "Enter into legitimate relations with a member of the sex; let your respectable mother determine your choice. . . . " Relations with a woman, in order not be diabolical, must be maternally supervised and censored.

Beyond this intense but "normal" love for a woman, the literature of the fantastic illustrates several transformations of desire. Most of them do not truly belong to the supernatural, but rather to a social form of the uncanny. Incest constitutes one of the most frequent varieties. In Perrault we find the criminal father in love with his daughter; the *Arabian Nights* report cases of love between brother and sister, between mother and son. In *The Monk*, Ambrosio falls in love with Antonia his own sister, rapes and murders her, after having killed their mother. In the Barkiarokh episode in *Vathek*, the hero's love for his daughter is all but gratified.

Homosexuality is another kind of love which the literature of the fantastic often accommodates. *Vathek* can serve as a further example here, not only in the description of the youths massacred by the Caliph or in that of Gulchenruz, but also and above all in the episode of Alasi and Firuz, in which the homosexual relation is belatedly attenuated: Prince Firuz is actually Princess Firuzkah. It is noted that the literature of this period often plays (as André Parreau points out in his book on Beckford) on an ambiguity as to the sex of the beloved: hence Biondetto-Biondetta in *Le Diable Amoureux*, Firuz-Firuzkah in *Vathek*, Rosario-Matilda in *The Monk*.

A third variety of desire may be characterized as "supernumerary love," *l'amour à trois* being the most common form. This type of love is anything but surprising in the oriental tales: thus the third calender in the *Arabian Nights* lives in

peace with his forty wives. In a scene of *The Saragossa Manuscript* quoted above, we saw Hervas in bed with three women, the mother and her two daughters.

Indeed, *The Saragossa Manuscript* offers several complex examples which combine the varieties enumerated so far. For example, the relation of Alfonso with Zibeddé and Emina: it is first of all homosexual, for the two girls live together, before encountering Alfonso. In her narrative of their youth, Emina constantly speaks of what she calls "our inclinations," of the "misery of living without each other," of the desire to "marry the same man," in order not to have to separate. This love is also incestuous, since Zibeddé and Emina are sisters (Alfonso, moreover, is also a relative, being their cousin). Finally, it is always an *amour à trois*: neither sister ever meets Alfonso alone. This is more or less the case for Pascheco, who shares the bed of Inesilla and Camilla (the latter declares: "I insist that one bed serve us all tonight"). Yet Camilla is Inesilla's sister, and the situation is still more complicated by the fact that Camilla is the second wife of Pascheco's father, and is thus to some extent his mother, and Inesilla his aunt.

The same work offers another variety of desire, related to sadism, in the instance of the Princess of Mont-Salerno who tells how she enjoyed "putting the obedience of my ladies-in-waiting to all kinds of tests. . . . I punished them either by pinching them or even by sticking pins into their arms and thighs," etc.

Here we touch on pure cruelty, whose sexual origin is not always apparent. This origin, on the other hand, may be identified in a passage of *Vathek* describing a sadistic pleasure:

> During these preparations, Carathis . . . made select parties of the fairest and most delicate ladies of the city. . . . But in the midst of their gaiety, she contrived to introduce vipers amongst them, and to break pots of scorpions under the table. They all bit to a wonder, and Carathis would have left her friends to die,

were it not that, to fill up the time, she now and then amused herself in curing their wounds, with an excellent anodyne of her own invention: for this good Princess abhorred being indolent.

The scenes of cruelty in *The Saragossa Manuscript* are of a related spirit. Here we have tortures which afford pleasure to the person who inflicts them. Witness a first example in which the cruelty is so intense that it is attributed to super-natural forces. Pascheco is tormented by the two demons on the gibbet:

Then the other hanged man, who had seized my left leg, tried to get his talons into me as well. First of all he began by tickling the sole of my foot, which was in his grasp. Then the monster tore off the skin, baring the nerves, which he separated each from the next and sought to play upon as if I were a stringed instrument; but since I produced no sound to his liking, he thrust his spur into my calf, pinched the tendons, and began to twist them, as one does in tuning a harp. Finally he began to play upon my leg, of which he had made a kind of psaltery. I heard his diabolic laughter.

Human beings rather than supernatural forces produce another scene notable for its cruelty in the same work. It occurs in the speech addressed to Alfonso by the false inquisitor:

My dear son, be not alarmed by what I am about to tell you. We are going to hurt you somewhat. You see those two boards. Your legs will be put between them, and they shall be tightened by a rope. Then we shall put between your legs the wedges you see here, and they shall be hammered into your joints. First your feet will swell. Then the blood will spurt from your big toes, and the nails of the other toes will all fall off. Then the soles of your feet will crack open, and out of them will protrude a pulpy mass of crushed flesh. This is going to hurt you a great deal. Utter not a word — for all of this is still only the ordinary

method of questioning. However, you will faint. Here are flagons, filled with various spirits, with which you will be revived. When you have returned to your senses, we shall remove those wedges and insert these, which are much larger. At the first stroke your knees and ankles will break. At the second, your legs will split up their entire length. The marrow will emerge from your bones and spill onto this straw, mixed with your blood. You will not speak? Ah, then we shall begin with your thumbs. . .

We might consider, by a stylistic analysis, the means by which this passage achieves its effect. The inquisitor's calm and methodical tone certainly plays some part in the matter, as does the precision of the terms designating the parts of the body. We may note as well that in the two last examples, what is involved is a purely verbal violence: the narratives do not describe events actually occurring in the universe of the book. Although one is in the past, the other in the future, both actually derive from an unreal, or what might be termed a virtual mode: they are narratives of threat. Alfonso does not experience these cruelties, does not even observe them; rather they are described, spoken in his presence. It is not the acts which are violent, since in fact there are no acts, but the words. The violence is performed not only *through* language (it can never be otherwise in literature), but also strictly *in* language. The act of cruelty consists in the articulation of certain sentences, not in a succession of effective acts.

The Monk affords another variety of cruelty, one that is not referred to its executant, and which therefore does not provoke a sadistic pleasure in the character: the verbal nature of the violence as well as its function for the reader thereby become still clearer. Acts of cruelty are not invoked here for purposes of characterization, but the pages where they are described reinforce and color the atmosphere of sensuality which suffuses the entire action. Ambrosio's death affords one example. The death of the prioress — the violence of

which Artaud powerfully emphasized in his French translation
— is even more horrible:

> The rioters heeded nothing but the gratification of their barbarous
> vengeance. They refused to listen to her: they showed her every
> sort of insult, loaded her with mud and filth, and called her by
> the most opprobrious appellations. They tore her from one
> another, and each new tormentor was more savage than the former.
> They stifled with howls and execrations her shrill cries for mercy,
> and dragged her through the streets, spurning her, trampling her,
> and treating her with every species of cruelty which hate or vindic-
> tive fury could invent. At length a flint, aimed by some well-
> directing hand, struck her full upon the temple. She sank upon
> the ground bathed in blood, and in a few minutes terminated her
> miserable existence. Yet though she no longer felt their insults,
> the rioters still exercised their impotent rage upon her lifeless
> body. They beat it, trod upon it, and ill-used it, till it became
> no more than a mass of flesh, unsightly, shapeless, and disgusting.

The chain which started with desire and led through
cruelty has led us to death. The relationship of these two
themes is, moreover, quite well known. Their relation is not
always the same, but one may say that it is always present.
In Perrault, for example, an equivalence is established
between sexual love and the infliction of death. The relation-
ship appears quite clearly in the story of "Little Red Riding-
Hood," which makes the act of disrobing and getting into
bed with a being of the opposite sex the equivalent of being
eaten and dying. "Bluebeard" repeats the same moral: the dried
blood on the key, which evokes menstrual blood, will lead
to the death sentence.

In *The Monk*, the relation of the two themes is one of
contiguity rather than equivalence. It is in trying to possess
Antonia that Ambrosio kills her mother; and it is after having
violated Antonia that he finds himself obliged to kill her. The
scene of the rape, moreover, is placed under a sign of the

proximity of desire and death: "By the side of three putrid half-corrupted bodies lay the sleeping beauty."

This variant of the relation, in which the desirable body is in proximity to the corpse, will be predominant in Potocki — but here we shift once again, this time from contiguity to substitution. The transformation of an attractive woman into a corpse is the pattern, repeated time and again, of the action in *The Saragossa Manuscript*. Alfonso falls asleep with the two sisters in his arms; upon waking he finds two corpses in their place. The same will be the case for Pascheco, Uzeda, Rebecca and Velásquez. The adventure of Thibaud de la Jacquière is even more morbid: the attractive woman to whom he believes he is making love becomes both devil and corpse: "Orlandina no longer existed. In her place Thibaud saw only a horrible assemblage of strange and hideous forms. . . . The next morning, peasants came to the place . . . and found Thibaud lying on a half-rotted cadaver." The difference from Perrault is clear: in the latter, death directly punishes the woman who yielded to her desires; in Potocki, it punishes the man by transforming the object of his desire into a corpse.

The relation is still different in Gautier. The priest of "La Morte Amoureuse" experiences a sensual derangement upon contemplating Clarimonde's dead body. Instead of rendering her odious to him, death, on the contrary, seems to augment his desire: "Shall I confess it to you? This perfection of forms, purified and sanctified as it was by the shadow of death, stirred me more voluptuously than it should have done." Later on that night, he is no longer content with contemplation. "The night was advancing, and feeling the moment of eternal separation approach, I could not deny myself that sad and supreme delight of placing one kiss upon the dead lips of the woman who had possessed all my love."

The love for death that is here presented in a somewhat veiled form (and which in Gautier is coupled with love for a statue, for an image in a painting, etc.), is known as necrophilia. In the literature of the fantastic, necrophilia habitually

assumes the form of a love consummated with vampires or
with the dead who have returned among the living. This relation
can once again be presented as the punishment for excessive
sexual desire; but it may be present also without its receiving
a negative value — as with the relation between Romuald
and Clarimonde for instance. The priest discovers that
Clarimonde is a female vampire, but this discovery produces
no change in his feelings. After having uttered a monologue
in praise of blood — before a Romuald she believes fast asleep —
Clarimonde turns to action.

> At last she made up her mind, pierced me lightly with her needle,
> and began to suck up the blood which flowed from the wound.
> Though she had drunk only a few drops, she was overcome with
> a fear of exhausting me, and she carefully wrapped a tourniquet
> around my arm after having rubbed the wound with an unguent
> which immediately caused the opening in the flesh to vanish. I
> could have no further doubts; the Abbé Serapion was right. Yet
> despite this certainty, I could not help loving Clarimonde, and
> I should gladly have given her all the blood she required in order
> to sustain her artificial existence. . . . I should have opened my
> veins myself and said to her: Drink then! and may my love enter
> your body even as my blood!

The relation between death and blood, love and life is here
obvious.

 When vampires and devils are "on the right side," we
must expect priests and religion itself to be condemned and
vilified with the worst names: even that of the devil! This
complete reversal, too, occurs in "La Morte Amoureuse."
Hence that incarnation of Christian morality, the Abbé
Serapion, who makes it a duty to unbury Clarimonde's body
and to kill her a second time: "Serapion's zeal had something
harsh and savage about it which made him resemble a devil
rather than an apostle or an angel. . . ." In *The Monk*,
Ambrosio is startled to find the naive Antonia reading the
Bible: " ' How!' said the friar to himself, 'Antonia reads the
Bible, and is still so ignorant?' "

We find, then, in various texts of the fantastic the same structure, though given different values. Either, in the name of Christian principles, intense if not excessive carnal love and all its tranformations are condemned or else they are praised; but the opposition to the spirit of religion, the mother, etc., is always the same. In the works where love is not condemned, supernatural forces intervene in order to effect its fulfillment. We find an example of this in the *Arabian Nights* as well: Aladdin manages to realize his desires with the help of magical instruments, the ring and the lamp; his love for the Sultan's daughter would have remained a dream forever without the intervention of the supernatural forces. The same is true in Gautier. By the life she preserves after death, Clarimonde permits Romuald to realize an ideal love, even if it is condemned by official religion (and we have seen that the Abbé Serapion is not far from resembling the devil himself). Hence it is not repentance which ultimately prevails in Romuald's soul: "I have missed her more than once," he will say, "and I miss her still." This theme receives its full development in Gautier's last fantastic tale, entitled "Spirite." Guy de Malivert, the hero of the tale, falls in love with the spirit of a dead girl; and thanks to the communication established between them, discovers the ideal love he had sought in vain among earthly women. This sublimation of the theme of love departs from the network of themes which concerns us here, and returns to the one previously discussed which encompasses the themes of the self.

Let us summarize our progress. The point of departure of this second thematic complex remains sexual desire. Literature of the fantastic is concerned to describe desire in its excessive forms as well as its various transformations or, one may say, its perversions. A special case must be made out for cruelty and violence, even if their relation with desire is in itself indubitable. Similarly, the preoccupations concerning death, life after death, and corpses and vampirism, are linked to the theme of love. The supernatural does not manifest

itself with equal intensity in each of these cases: it makes its appearance in order to give the measure of sexual desires which are especially powerful and in order to introduce us into life after death. On the other hand, cruelty or human perversions generally do not surpass the limits of the possible, and we are here concerned with what we might call the socially uncanny and improbable.

We saw that the "themes of the self" could be interpreted as so many definitions of the relation between man and the world, of the perception-consciousness system. Here, in considering the "themes of the other," nothing of the kind is so: if we wish to interpret the themes of the other on the same level of generality, we must say that they concern, rather, the relation of man with his desire — and thereby with his unconscious. Desire and its variations, including cruelty, are so many figures representing the relations between human beings. At the same time, man's possession by what we may call his "instinct" raises the problem of the structure of the personality, of its internal organization. If the themes of the self implied an essentially passive position, we note here, by way of distinction, a powerful *action* on the surrounding world: man no longer remains an isolated observer, he enters into a dynamic relation with other men. Lastly, if we may assign the "themes of vision" to the first network (i.e. to that which comprises the themes of the self) because of the importance which the sense of sight and perception in general assume, here we must speak of the "themes of discourse." For language is, in fact, the form par excellence, and the structuring agent, of man's relation with other men. Or, as Henry James says in "The Question of Our Speech":

All life therefore comes back to the question of our speech, the medium through which we communicate with each other, for all life comes back to the question of our relations with one another.

9

themes of the fantastic: conclusion

We have just established two thematic complexes which are distinguished by their distribution — and we have seen that when the themes of the first network appear at the same time as those of the second, it is precisely to indicate that there is an incompatibility, as in *Louis Lambert* or in "The Hashish Club." It remains for us to draw our conclusions from this distribution of themes.

Our approach to the themes that have just been treated is a rather limited one. If we compare our observations on *Aurélia*, for example, with what a thematic study of this work reveals, we discover that there exists between the two a difference of nature (quite independent of any value judgment we may bring to bear, of course). Generally, when a thematic study speaks of the double, or of woman, time or space, an attempt is made to reformulate the meaning of the text in more explicit terms. In collecting the themes, the author of such a study interprets them; in paraphrasing the text, he specifies its meaning.

The attitude taken here has been quite different. We have not tried to interpret the themes, but solely to establish their presence. Rather than to seek to give an interpretation of desire as it is manifested in *The Monk*, for example, or of

death in "La Morte Amoureuse" — as a thematic critic would have done — we have been content to indicate their existence. The result is knowledge simultaneously more limited and less disputable.

Two different objects, *structure* and *meaning,* are implied here by two distinct activities: *poetics* and *interpretation.* Every work possesses a structure, which is the articulation of elements derived from the different categories of literary discourse; and this structure is at the same time the locus of the meaning. In poetics, one rests content with establishing the presence of certain elements within a literary work. But it is possible to achieve a high degree of certainty, for such knowledge may be verified by a series of procedures. The interpretive critic undertakes a more ambitious task: that of specifying — or it might be said of *naming* — the work's meaning. But the result of this activity cannot claim to be either scientific or "objective." There are, of course, some interpretations that are more justified than others; but none can assert itself as the only right one. Poetics and criticism are therefore but instances of a more general opposition, between science and interpretation. This opposition, both terms of which, moreover, are equally worthy of interest, is never pure in practice; only an emphasis on one or the other activity permits us to keep them distinct.

It is anything but an accident if, in studying a genre, we have taken the perspective of poetics. Genre represents, precisely, a structure, a configuration of literary properties, an inventory of options. But a work's inclusion within a genre still teaches us nothing as to its meaning. It merely permits us to establish the existence of a certain rule by which the work in question — and many others as well — are governed.

Let us add that the two activities each have a preferred object: that of poetics is literature in general, with all its categories (whose various combinations form genres); that of interpretation, on the other hand, is the particular work. What interests the critic is not what the work has in common

with the rest of literature, but whatever is specific about it. This difference in aim naturally provokes a difference in method: whereas for the *poetician* what matters is the knowledge of an object external to him, the critic tends to identify himself with the work, to constitute himself as its subject. Returning to our discussion of thematic criticism, let us note that such criticism finds, in the perspective of interpretation, the justification it lacked in the eyes of poetics. We have declined to describe the organization of images, which occurs on the very surface of the text; but it does nonetheless exist. One may legitimately observe the relation that is established within a text between the color of a ghost's face, the shape of the trap door through which it vanishes, and the singular odor that remains following the ghost's disappearance. Such a task, which is incompatible with the principles of poetics, finds its place in the context of interpretation.

There would be no need to evoke this opposition if it were not themes, precisely, that are in question here. In general we accept the existence of two points of view, that of criticism and that of poetics, when we are concerned with the verbal or syntactical aspects of a work: phonic or rhythmic organization, the choice of rhetorical figures or of methods of composition, have long since been the object of more or less rigorous study. But the semantic aspect — or the themes of literature — has hitherto escaped such study: just as in linguistics we have until recently tended to exclude meaning, and consequently semantics, from the limits of knowledge in order to concern ourselves only with phonology and syntax, so in literary studies a theoretical approach to "formal" elements of the work, such as rhythm and composition, has been accepted only to be rejected as soon as "content" is in question. Yet we have seen to what degree the opposition between form and content is an irrelevant one; we may however distinguish between a structure constituted by all the literary elements — including the themes on one hand, and on the other the meaning a critic will assign not

only to the themes, but also to all the aspects of the work. We know for instance that in certain periods poetic rhythms (iamb, trochee, etc.) have been assigned affective interpretations: gay, sad, etc. We have observed here, in fact, that a stylistic procedure such as modalization can have a specific meaning, as in *Aurélia*: it signifies in that context the hesitation proper to the fantastic.

We have therefore tried to undertake a study of themes which would place them on the same level of generality as poetic rhythms; with that end in view we have established two thematic systems without claiming thereby to give an interpretation of these themes, as they appear in each particular work. The point is restated here in order to avoid any misunderstanding with regard to the scope and ambitions of the present essay.

It is necessary to point out another possible error, with regard to the way in which literary images, as they have been identified up till now, are to be understood. In establishing our two networks of themes, we have put side by side certain abstract terms — sexuality, death — and certain concrete terms — the devil, vampires. In doing so, we have not tried to establish a relation of signification between the two groups (such as: the devil *means* sex; the vampire *means* necrophilia) but rather a compatibility, a *co-presence*. The meaning of an image is always richer and more complex than any such translation would suggest, and this for several reasons.

First of all, there are grounds for speaking of a polysemy of the image. Let us take, for instance, the theme (or image) of the double. It figures in many texts of fantastic literature; but in each particular work the double has a different meaning, which depends upon the relations that this theme sustains with others. Such significations can even be opposed to one another, as they are in Hoffmann and Maupassant. The double's appearance is a cause for joy in the works of the former:

it is the victory of mind over matter. But in Maupassant, on the contrary, the double incarnates danger: it is the harbinger of threat and terror. Again, there are contrary meanings in *Aurélia* and *The Saragossa Manuscript*. In Nerval, the double's appearance signifies, among other things, a dawning isolation, a break with the world; in Potocki, quite the contrary, the doubling that is so frequent throughout the book becomes the means of a closer contact with others, of a more complete integration. Hence it is not surprising to find the image of the double in both thematic systems as we have established them: such an image may belong to different structures, and it may also have several meanings.

Moreover, the very notion of seeking a direct equation must be rejected, because each image always signifies others, in an infinite network of relations; and further, because it signifies *itself*: it is not transparent, but possesses a certain density. Otherwise, we should consider all images as allegories (and we have seen that allegory implies an explicit indication of another meaning, which makes it a very specific case). Hence we shall not follow Penzoldt when he writes, apropos of the genie which comes out of the bottle in the *Arabian Nights*: "The genie is obviously the personification of desire, whereas the bottle's cork, tiny and weak as it is, represents man's moral scruples." We reject this way of reducing an image to a signifier whose signified is a concept. Moreover, this would imply the existence of a limit set up between the two, which is, as we shall see below, unthinkable.

After having tried to make our procedure explicit, we must try to make its results intelligible. To do so, we must understand both the nature of the opposition of the two complexes of themes and what categories it brings into play. Let us first return to the relations already sketched between these thematic systems and other more or less familiar organizations: this comparison may permit us to advance further into the

nature of the opposition, to give it a more precise formulation. Yet there will thereby be some loss as to the certainty with which we might confirm our thesis. This is not just a matter of speaking: all that follows has a purely hypothetical character, and must be taken as such.

Let us begin with the analogy observed between the first network (the one that encompasses the themes of the self) and the universe of childhood as it appears to the adult (according to Piaget's account). We may wonder as to the reason for this resemblance. The answer will be found in the same studies of genetic psychology to which we have referred: the essential event which provokes the shift from the primary mental organization to maturity (through a series of intermediate stages) is the subject's accession to language. It is this accession which makes these particular features disappear in the first period of mental life: the absence of distinction between mind and matter, between subject and object; and the pre-intellectual conceptions of causality, space, and time. One of Piaget's contributions is to have shown that the transformation from primary mental organization to maturity functions precisely because of language, even when this is not immediately apparent. Thus, for example, in the case of time: "The child becomes, by language, capable of reconstructing his past actions in the form of narrative and of anticipating his future actions by verbal representation." We recall that time was not, in the earliest period of our childhood, the line joining these three points (past, present, and future), but rather an eternal present — obviously very different from the present we know, which is a verbal category — something elastic or infinite.

We are thus led back to the second of the analogies we had drawn: the one between this same thematic complex and the world of drugs. There — in the drug world — we met with a similarly inarticulate and fluid conception of time. Here again we face a world without language, for drugs reject verbalization. And to proceed a step further, we may say that

the *other* has no autonomous existence here, that the self — the *I* — identifies with it, without conceiving it as something independent.

Another point common to the universe of childhood and the drug universe concerns sexuality. It will be recalled that the opposition which permitted us to establish the existence of two clusters of themes concerned, precisely, sexuality (in *Louis Lambert*). Sexuality (or more specifically, its common and elementary form) is excluded both from the drug world and from that of the mystics. The problem seems more complex with regard to childhood. The infant does not live in a world without desire; but his desire is first of all "auto-erotic." The discovery which then ensues is that of desire oriented toward an object. The state of transcendence that is achieved through drugs (a transcendence sought by the mystics as well), and which we may describe as *pan-erotic* is itself a transformation of sexuality related to "sublimation." In the former case, desire lacks an external object; in the latter, its object is the whole world; between the two is situated "normal" desire.

Now we come to the third analogy suggested in the course of our study of the "themes of the self": the one having to do with psychosis. Here again, the terrain is uncertain. We must rely on descriptions (of the psychotic world) made from the viewpoint of the "normal man." The behavior of the psychotic is evoked here not as a coherent system but as the negation of another system, as a deviation. When we speak of the "world of the schizophrenic" or the "world of the child," we are operating with no more than simulacra of these states, as they have been elaborated by the non-schizophrenic adult. The schizophrenic, we are told, rejects communication and inter-subjectivity. And this renunciation of language leads him to live in an eternal present. In the place of common language, he establishes a "private language" (which of course is a contradiction in terms, and hence an *anti-language*). Words borrowed from the common lexicon receive new mean-

ings, which the schizophrenic keeps individual: it is not simply a matter of varying the meaning of words, but of preventing words from effecting an automatic transmission of this meaning. "The schizophrenic, " Kasanin writes, "has no intention of changing his method of utterly individual communication, and seems to take pleasure in the fact that you do not understand him." Language thus becomes a means of cutting oneself off from the world, contrary to its conventional mediating function.

The worlds of childhood, drugs, schizophrenia, and mysticism form, in each case, a paradigm to which the themes of the self belong equally (which does not mean that important differences among them do not exist). Moreover, the relations among these terms, taken in pairs have often been remarked. Balzac wrote in *Louis Lambert*: "There are certain works by Jakob Boehme, Swedenborg, or Mme Guyon which when read carefully invoke fantasies as various as any dreams produced by opium." The world of the schizophrenic, furthermore, has often been compared with that of the infant. Finally, it is no accident that the mystic Swedenborg was a schizophrenic; nor that the use of certain powerful drugs can lead to psychotic states.

It would be tempting, at this point, to relate our second grouping, the "themes of the other," to that other great category of mental diseases: the neuroses. A superficial rapprochement might be based on the fact that the decisive role of sexuality and its variations in the second thematic system seems, in fact, to be rediscovered in the neuroses: perversions, as has often been remarked since Freud, are the exact "negative" of the neuroses. We remain conscious of the risk of oversimplification that arises, here as before, as a consequence of these borrowed concepts. If we permit ourselves to establish certain convenient transitions between psychosis and schizophrenia, between neurosis and perversion, it is because we believe we are taking up a position on a high enough level of generality. Our assertions are admittedly approximate.

The relation becomes much more significant once we appeal to psychoanalytic theory in order to establish this typology. Here is how Freud approached the problem shortly after his second formulation of the structure of the psyche: "Neurosis is the result [*Erfolg*] of a conflict between the ego and its id; whereas psychosis is the analogous result of a similar disturbance in the relations between the ego and the external world." In order to illustrate this opposition, Freud cites the following example:

> A young woman who was in love with her brother-in-law, and whose sister was dying, was horrified by the thought: "Now he is free and we can be married!" The instantaneous forgetting of this thought permitted the initiation of the process of repression which led to hysterical disturbances. Nonetheless it is interesting to see, in just such a case, how neurosis tends to resolve the conflict. It takes into account the change in reality by repressing the satisfaction of the impulse, in this case, the love for the brother-in-law. A psychotic reaction would have denied the fact that the sister was dying.

We are here very close to our own division. We have seen that the "themes of the self" were based on a break in the limits between the psychic and the physical realms: to think that someone is not dead — to desire it on one hand, and to perceive this same fact in reality on the other — are two phases of one and the same movement, and the transition between them is accomplished without difficulty. In the other key, the hysterical consequences of repressing love for the brother-in-law resemble those "excessive" acts linked to sexual desire that we have encountered in enumerating the "themes of the other."

What is more: we have already discussed, apropos of the themes of the self, the essential role of perception, of the relation with the external world; here we are once again at the origin of psychosis. We have also seen that it is not possible to conceive the "themes of the other" without taking

into account the unconscious and the impulses whose repression creates neurosis. We are thus entitled to say that, on the level of psychoanalytic theory, the network of themes of the self corresponds to the system of perception-consciousness; and that the network of themes of the other corresponds to the system of unconscious impulses. We must note here that the relation with others, on the level where it concerns the literature of the fantastic, is to be found in this second group. In noting this analogy, we do not mean that neuroses and psychoses are to be found in this literature, or conversely, that all the themes of this literature are to be found in the manuals of psychopathology.

But here a new danger arises. All these references may suggest that we are quite close to the so-called psychoanalytic school of criticism. In order to situate and differentiate more clearly our own position, we shall therefore briefly consider this critical approach. Two examples seem particularly appropriate here: the pages Freud himself devoted to the uncanny, and Penzoldt's book on the supernatural.

In Freud's study of the uncanny, we must acknowledge the double character of psychoanalytic investigation. It is as if psychoanalysis were at once a science of structures and a technique of interpretation. In the first case, it describes a mechanism — the mechanism, one might say, of psychic activity. In the second case, it reveals the ultimate meaning of the configurations so described. It answers both the question "how" and the question "what."

Here is an illustration of this second approach, in which the analyst's activity may be defined as a decoding: "Whenever a man dreams of a place or a country and says to himself, still in the dream, *This place is familiar to me, I have been here before*, we may interpret the place as being his mother's genitals or her body." The oneiric image here described is taken in isolation, independent of the mechanism of which it constitutes a part; on the other hand, we are given its meaning; this meaning is qualitatively different from the

images themselves; the number of ultimate meanings is limited and immutable. Or again:

> To many people the idea of being buried alive while appearing to be dead is the most uncanny thing of all. And yet psychoanalysis has taught us that this terrifying fantasy is only the transformation of another fantasy which originally had nothing terrifying about it at all, but was on the contrary filled with a certain lustful pleasure — the fantasy, I mean, of intra-uterine existence.

Here we are again confronted with a translation: a certain phantasmic image has a certain content.

Yet there exists another attitude, in which the psychoanalyst no longer tends to decipher the ultimate meaning of an image, but rather seeks to link two images together. Analyzing Hoffmann's "The Sandman," Freud writes: "This automaton (Olympia) can be nothing else than a personification of Nathaniel's feminine attitude toward his father during his infancy." The equation Freud establishes no longer links merely an image and a meaning (though it still does that), but links two textual elements: the doll Olympia and Nathaniel's childhood, both present in Hoffmann's tale. Thereby, Freud's remark enlightens us less as to the interpretation of the language of images than as to the mechanism of this language, its internal functioning. In the first case, we might compare the psychoanalyst's activity to that of a translator; in the second, it is related to that of the linguist. Many examples of both types of activity can be found in *The Interpretation of Dreams*.

Of these two possible directions of inquiry, we shall pursue only one. The attitude of the *translator* is, as we have said, incompatible with our position with regard to literature — for we believe that literature means nothing but itself, and therefore that no "translation" is necessary. What we are attempting, on the other hand, is to describe the functioning of the literary mechanism (though it is true that there is no fixed limit between translation and description . . .). It is in

this sense that the experience of psychoanalysis can be useful to us (psychoanalysis understood here as but one branch of semiotics). Our reference to the structure of the psyche derives from this kind of borrowing; and the theoretic procedures of a René Girard may here be considered as exemplary.

When psychoanalysts have been concerned with literary works, they have not been content to describe them, on any level whatever. Beginning with Freud, they have always tended to consider literature as one means among others of penetrating the author's psyche. Literature is thus reduced to the rank of a simple symptom, and the author constitutes the real object of study. Thus, after having described the organization of "The Sandman," Freud indicates, without transition, what in the author may account for it: "Hoffmann was the child of an unhappy marriage. When he was three, his father abandoned his small family and never returned to it," etc. This attitude, frequently criticized subsequently, is no longer in fashion today; it is nonetheless necessary to specify the reasons for our rejection of it.

It is not enough to say, in fact, that we are interested in literature and in literature alone, and that we therefore reject any information as to the author's biography. Literature is always more than literature, and there are certainly cases in which the writer's biography stands in a relevant relation to his work. But in order to be usable, this relation must be given as one of the features of the work itself. Hoffmann, who was an unhappy child, describes the fears of childhood; but for this observation to have an explicative value, we must prove either that all writers unhappy in childhood do the same, or that all descriptions of childhood fears are by writers whose childhoods were unhappy. Since we cannot establish the existence of one relation or the other, to state that Hoffmann was unhappy as a child is no more than to indicate a coincidence devoid of explicative value.

From all of which we must conclude that literary studies will gain more from psychoanalytic writings concerning the

structures of the human subject in general than from those dealing with literature. As often happens, the too-direct application of a method in a realm other than its own merely results in reiteration of the initial presuppositions.

In summarizing earlier the thematic typologies that have been proposed in various essays on the literature of the fantastic, we left Penzoldt's to one side, as qualitatively different from the others. Indeed, whereas most authors classified the themes under rubrics such as vampire, devil, witch, etc., Penzoldt suggests grouping them according to their psychological origin. This origin has a double locus: the collective unconscious and the individual unconscious. In the first case — the collective unconscious — the thematic elements are lost in the night of time; they belong to all humanity, and the poet is merely more sensitive to them than others, and thereby manages to externalize them. In the second case, we are dealing with personal and traumatizing experiences: a certain neurotic writer will project his symptoms into his work. This is particularly the case in one of Penzoldt's sub-genres which he calls the "pure horror tale." For the authors he links to it, "the fantastic tale is nothing but a surfacing of disagreeable neurotic tendencies." But these tendencies are not always distinctly manifest outside the work. Hence, the case of Arthur Machen, the neurotic character of whose writings may be explained by the puritanical education he had received: "Fortunately, in his life Machen was not a puritan at all. Robert Hillyer, who knew him well, tells us that he liked good wine, good company, good jokes, and that he led a perfectly normal married life. . . . We are told he was an enchanting friend and a perfect father," etc.

We have already said why it is impossible to admit a typology based on the biography of authors. Penzoldt here affords us, moreover, a counter-example. No sooner has he said that Machen's education explains his work than he finds himself obliged to add, "fortunately, the man Machen was quite different from the writer Machen. . . . Thus Machen

lived the life of a normal man, whereas a part of his work became the expression of a terrible neurosis."

Our rejection has a further motive. For a distinction to be valid in literature, it must be based on literary criteria, and not on the existence of psychological schools, each of which prevails in a certain field. The distinction between collective unconscious and individual unconscious, whether or not it is valid in psychology, has no *a priori* literary pertinence: the elements of the "collective unconscious" mingle freely with those of the "individual unconscious," according to the analyses of Penzoldt himself.

We can now return to the opposition of our two thematic complexes.

We have not exhausted, of course, either of the two paradigms to which the distribution of fantastic themes has opened the way. It is possible, for instance, to find an analogy between certain social structures (or even certain political regimes) and the two networks of themes. Or again, the opposition that Mauss sets up between religion and magic is very close to the one we have established between themes of the self and themes of the other:

While religion tends toward metaphysics and is absorbed in the creation of ideal images, magic, through a thousand fissures, emerges from the mystical life from which it draws its forces to mingle with profane life and to serve it. It tends to the concrete even as religion tends to the abstract.

One proof among others: mystical meditation is a-verbal, whereas magic cannot do without language. "It is doubtful that there have been authentic mute rites, whereas it is certain that a very great number of rites have been exclusively oral."

We understand better now that other pair of terms which we had introduced in speaking of themes of *vision* and of

discourse (though we must employ these words with caution). Once again, moreover, the literature of the fantastic has initiated its own theory: in Hoffmann, for instance, we find a distinct consciousness of this opposition. He writes: "What are words? Nothing but words! Her heavenly gaze says more than all the languages in the world!" Or again: "You have seen the splendid sight which one might call the finest in the world, since it expresses so many deep feelings without the help of language." Hoffmann, an author whose tales exploit themes of the self, does not conceal his preference for vision, as opposed to discourse. It must be added here that in another sense, the two thematic systems can be considered as equally linked to language. The "themes of vision" are based on a breakdown of the limit between psychic and physical; but one could reformulate this observation from the point of view of language. Here the themes of the self cover, as we have seen, the possibility of breaking down the limit between literal and figurative meaning: the themes of the other are formed out of the relation established between two interlocutors, during their discourse.

The series might be continued indefinitely, without its ever being legitimate to say that one of the pairs of opposed terms is more "authentic" or more "essential" than another. Psychosis and neurosis are not the explication of the themes of fantastic literature, any more than the opposition between childhood and maturity is. There are not two types of units of different nature, signifying and signified, the latter forming the stable residue of the former. We have established a chain of correspondences and relations which might present the fantastic themes as a point of departure ("to be explained") as well as a point of arrival ("explanation"); and the same is true of all the other oppositions.

It remains to specify the place of the typology of fantastic themes we have just sketched in relation to a general typology

of literary themes. Without going into detail (to do so would show that this question is justified only if we give a proper acceptation to each of the terms which compose it), we may return now to the hypothesis posited at the beginning of this discussion. Let us say that our thematic division bisects *all* literature; but that it manifests itself in a particularly clear manner in fantastic literature, where it achieves its superlative degree. The literature of the fantastic is a kind of narrow but privileged terrain, starting from which we may draw certain hypotheses concerning literature in general. This remains to be verified, of course.

It is hardly necessary to explain further the names we have given to these two networks of themes. The *self* signifies the relative isolation of man in the world he constructs — the accent resting on that confrontation without an intermediary having to be named. The *other,* in contrast, refers precisely to that intermediary, and it is the third relation which is at the basis of the network. This opposition is asymmetrical: the *self* is present in the *other*, but not conversely. As Martin Buber writes: "There is no *I* taken in itself, but only the *I* of the primary word *I-Thou* and the *I* of the primary word *I-It*. When a man says *I*, he refers to one or the other of these."

Further, the *I* and the *Thou* — that is, the self and the other — designate the two participants in the act of discourse: the one who speaks and the one addressed. If we put the emphasis on these two interlocutors, it is because we believe in the primordial importance of the situation of discourse, as much for literature as for what is outside it. A theory of personal pronouns, studied from the viewpoint of the process of speech acts, could explain many important properties of every verbal structure. This is a task which remains to be accomplished.

At the beginning of this study of themes, we formulated two chief requirements for the categories to be discovered: they must be abstract and they must be literary. The categories

of *self* and *other* have indeed this double characteristic: they possess a high degree of abstraction, and they remain internal to language. It is true that the categories of language are not necessarily literary categories — but here we touch on that paradox which all reflection upon literature must confront: a verbal formula concerning literature always betrays the nature of literature, because literature is itself paradoxical, constituted of words but signifying more than the words, at once verbal and transverbal.

Granted that there are two such categories, Todorov's illustration of them here is weak !

10

literature and the fantastic

Our survey of the genre of the fantastic is over. First of all, we have given a definition of the genre: the fantastic is based essentially on a hesitation of the reader — a reader who identifies with the chief character — as to the nature of an uncanny event. This hesitation may be resolved so that the event is acknowledged as reality, or so that the event is identified as the fruit of imagination or the result of an illusion; in other words, we may decide that the event *is* or *is not*. Further, the fantastic requires a certain type of reading — otherwise, we risk finding ourselves in either allegory or poetry. Finally, we have reviewed other properties of the fantastic work: properties which, without being obligatory, do appear with sufficiently significant frequency. These properties may be distributed according to the three aspects of the literary work: verbal, syntactical, and semantic (or thematic). Without studying any particular work in detail, we have instead tried to elaborate a general framework in which precisely such concrete studies might take their place; the term "approach" which appears in the title of this essay is not a figure of speech.

Our investigation has hitherto been located *within* the genre. We have sought to produce an "immanent" study of

the fantastic, to distinguish the categories by which it might be described, supported by internal necessities alone. We must now, in conclusion, change our perspective. Once the genre is constituted, we may consider it from the outside — from the viewpoint of literature in general, or even of social life — and ask our initial question again, though in another form: no longer "what is the fantastic?" but "*why* is the fantastic?" The first question dealt with the structure of the genre; this second one deals with its functions.

This question of function, moreover, is one which can be immediately subdivided and thereby leads to several particular problems. It can bear on the *fantastic*, i.e., on a certain reaction to the supernatural; but it can also bear on the supernatural itself. In view of which, we must again distinguish between a *literary function* and a *social function* of the supernatural. Let us begin with the second.

We find the germ of an answer in a remark of Peter Penzoldt's: "for many authors, the supernatural was merely a pretext to describe things they would never have dared mention in realistic terms." We may doubt that supernatural events are merely pretexts; but there is certainly a degree of truth in this assertion: the fantastic permits us to cross certain frontiers that are inaccessible so long as we have no recourse to it. Summarizing the supernatural elements, as previously enumerated, we shall see the justice of this observation. Take, for example, the "themes of the other": incest, homosexuality, love for several persons at once, necrophilia, excessive sensuality.... It is as if we were reading a list of forbidden themes, established by some censor: each of these themes has often been banned as a matter of fact, and may still be so in our own day. The fantastic coloration, moreover, has not always saved works from the censor's severity: *The Monk,* for example, was forbidden when it was republished.

Apart from institutionalized censorship, there is another kind, more subtle and more general: the censorship which

functions in the psyche of the authors themselves. The penalization of certain acts by society provokes a penalization invoked in and by the individual himself, forbidding him to approach certain taboo themes. More than a simple pretext, the fantastic is a means of combat against this kind of censorship as well as the other: sexual excesses will be more readily accepted by any censor if they are attributed to the devil.

If the group of themes of the other derives directly from taboos and hence from censorship, the same is the case for the network of themes of the self, though less directly. It is not an accident that this group refers us to madness. The thought of the psychotic is condemned by society no less severely than behavior of the criminal who transgresses taboos: the madman, like the criminal, is imprisoned and his jail is called an asylum. Nor is it an accident if society represses the use of drugs and, once again, imprisons those who use them, for drugs provoke a mode of thought which is similarly adjudged culpable.

We may therefore schematize the condemnation which affects the two groups of themes and say that the introduction of supernatural elements is an expedient to avoid this condemnation. We now understand better why our typology of themes coincided with that of mental diseases: the function of the supernatural is to exempt the text from the action of the law, and thereby to transgress that law.

There is a qualitative difference between the personal possibilities of a nineteenth-century author and those of a contemporary author. We may recall the devious means a Gautier had to employ in order to describe his character's necrophilia, the whole ambiguous business of vampirism. One need merely read, to indicate the distance, a page of Georges Bataille's *Le Bleu du Ciel*, which deals with the same perversion. When asked to explain himself, the narrator replies:

"Only one thing happened to me: I spent a night in an apartment where an elderly woman had just died — she was in her bed,

just like anyone else, between two candles, her arms at her sides, but her hands not clasped. There was no one in the room during the night. At that moment I understood." "How?" "I wakened around three in the morning. I had an impulse to go into the room where the corpse was. I was terrified, but no matter how much I trembled, I stayed in front of that corpse. Finally I took off my pajamas." "How far did you go?" "I didn't move, I was insane with anxiety; it happened quite separately, all by itself, just by watching." "Was the woman still attractive?" "No, quite old and withered."

Why can Bataille permit himself to describe directly a desire Gautier dares evoke only indirectly? We may suggest the following answer: in the interval between the publication of the two books has occurred an event whose best known consequence is the appearance of psychoanalysis. We are beginning to forget today the resistance to psychoanalysis in its early days, not only on the part of the learned who did not believe in it, but also and especially on the part of society. A change has occurred in the human psyche, a change of which psychoanalysis is the sign; and this very change has revoked that social censorship which forbade dealing with certain themes — and which would certainly not have authorized publication of *Le Bleu du Ciel* in the nineteenth century. (Though, of course, this book could not have been written then either. It is true that Sade lived in the eighteenth century; but on the one hand, what is possible in the eighteenth century is not necessarily so in the nineteenth; on the other, the dryness and simplicity of Bataille's description implies an attitude on the narrator's part which was inconceivable previously.) Which does not mean that the advent of psychoanalysis has destroyed the taboos; they have simply been shifted.

To proceed a step further: psychoanalysis has replaced (and thereby has made useless) the literature of the fantastic. There is no need today to resort to the devil in order to speak of an excessive sexual desire, and none to resort to vampires

in order to designate the attraction exerted by corpses: psychoanalysis, and the literature which is directly or indirectly inspired by it, deal with these matters in undisguised terms. The themes of fantastic literature have become, literally, the very themes of the psychological investigations of the last fifty years. We have already seen several illustrations of this; here we need merely mention that the double was even in Freud's time the theme of a classic study (Otto Rank's *Der Doppelgänger*); and that the theme of the devil has been the object of numerous studies (notably Theodor Reik's *Der eigene und der fremde Gott* and Ernest Jones' *The Connections Between the Nightmare and Certain Medieval Superstitions*), etc. Freud himself studied a case of demoniacal possession dating from the seventeenth century and declared, following Charcot, "We must not be surprised if the neuroses of these remote periods appear in a demonological disguise."

Here is another but less obvious example of the parallel between the themes of fantastic literature and those of psychoanalysis. We have observed, in the network of themes of the self, what we have called the action of pan-determinism. This is a generalized causality which does not admit the existence of chance and which posits that there are always direct relations among all phenomena, even if these relations generally escape us. Now, psychoanalysis acknowledges precisely this same seamless determinism in the field, at least, of man's psychic activity. "In the psychic life, there is nothing arbitrary, nothing undetermined," Freud writes in the *Psychopathology of Everyday Life*. Hence the realm of superstitions (which are nothing but a belief in pan-determinism) is one of the psychoanalyst's preoccupations. Freud indicates in his commentary the shift that psychoanalysis could introduce in this realm:

That ancient Roman who abandoned his plan because he had just seen an inauspicious flight of birds was relatively right; he was acting in accord with his premises. But when he abandoned

his plan because he had stumbled on his own threshold, he showed himself superior to us in our incredulity, and he revealed himself to be a better psychologist than we are. That stumble was for him the proof of the existence of doubt, of an internal opposition to his plan, a doubt and an opposition whose power could annihilate the power of his intention at the very moment of carrying out the plan.

The psychoanalyst's attitude here is analogous to that of the narrator of a fantastic tale in asserting that a causal relation exists between apparently unrelated facts.

More than one reason, then, justifies the following ironic remark of Freud's:

> The Middle Ages, quite logically and more or less correctly from the psychological viewpoint, attributed all these morbid manifestations to the influence of demons. Nor should I be surprised to learn that psychoanalysis, which is concerned to discover these secret forces, has thereby become strangely disturbing in the eyes of many people.

After this consideration of the social function of the supernatural, let us return to literature, this time observing the functions of the supernatural within the work itself. We have already answered this question once: setting aside allegory, in which the supernatural elements tend to illustrate an idea, we have distinguished three functions. There is a pragmatic function: the supernatural disturbs, alarms, or simply keeps the reader in suspense. A semantic function: the supernatural constitutes its own manifestation, it is an auto-designation. Lastly, a syntactical function: the supernatural enters, as we have said, into the development of the narrative. This third function is linked, more directly than the other two, to the whole of the literary work; it is now time to make this explicit.

There exists a curious coincidence between the authors who cultivate the supernatural and those who, within their works, are especially concerned with the development of the

action, or to put it another way, who seek above all to tell *stories*. The fairy tale gives us the first, and also the stablest, form of narrative. Now, it is in the fairy tale that we initially find certain supernatural events. The *Odyssey,* the *Decameron, Don Quixote* all possess, to different degrees it is true, elements of the marvelous, they are also the greatest narratives of the past. In modern times, the same is true: it is the narrators — Balzac, Mérimée, Hugo, Flaubert, Maupassant — who write fantastic tales. One cannot assert a relation of implication here, for there are authors whose narratives make no appeal to the supernatural; but the coincidence remains too frequent to be gratuitous. H.P. Lovecraft noticed this phenomenon: "Like most authors of the fantastic," he writes, "Poe is more comfortable in incident and in the larger narrative effects than in the drawing of character."

In order to explain this coincidence, we must inquire briefly into the very nature of narrative. Let us begin by constructing an image of the minimum narrative, not the kind we usually find in contemporary texts, but that nucleus without which we cannot say there is any narrative at all. The image will be as follows: *All narrative is a movement between two equilibriums which are similar but not identical.* At the start of the narrative, there is always a stable situation; the characters form a configuration which can shift but which nonetheless keeps a certain number of fundamental features intact. Let us say for instance that a child lives with his family; he participates in a micro-society which has its own laws. Subsequently, something occurs which introduces a disequilibrium (or, one might say, a negative equilibrium); thus for one reason or another the child leaves his house. At the end of the story, after having overcome many obstacles, the child — who has grown up in the meantime — returns to the family house. The equilibrium is then re-established, but it is no longer that of the beginning: the child is no longer a child, but has become an adult among the others. The elementary narrative thus includes two types of episodes: those which describe a state

of equilibrium or disequilibrium, and those which describe the transition from one to the other. The first are opposed to the second as statics is opposed to dynamics, stability to modification, adjective to verb. Every narrative includes this fundamental schema, though it is often difficult to recognize: its beginning or its end may have been suppressed, digressions — even entire distinct narratives — may have been interspersed, etc.

Now let us attempt to place the supernatural events within this schema. For instance let us take the story of the loves of Kamaralzaman from the *Arabian Nights*. Kamaralzaman, the son of the King of Persia, is the most intelligent as well as the most handsome youth not only in the kingdom but even beyond its borders. One day, his father decides that he must marry off his son — but the young prince suddenly discovers in himself an insurmountable aversion to women, and categorically refuses to obey. To punish him, his father imprisons his son in a tower. Here is a situation (of disequilibrium) which might well last some ten years. It is at this moment that the supernatural element intervenes. The *jinniyah* Maymunah discovers the handsome young man one day in her peregrinations, and is delighted by him. She then meets an *ifrit,* Dahnash, who knows the daughter of the King of China — the latter apparently the loveliest princess in the world, but who stubbornly refuses to marry anyone. In order to compare the beauty of these two characters, the *ifrit* and the *jinniyah* transport the sleeping princess to the bed of the sleeping prince. They then awaken the pair and observe them. There follows a whole series of adventures during which the prince and the princess try to rejoin each other, after this fugitive nocturnal encounter. At the end, they succeed and form a family in their turn.

Here we have an initial equilibrium and a final equilibrium, each of which is perfectly realistic. The supernatural event intervenes to break the median disequilibrium and to provoke the long quest for the second equilibrium. The supernatural

appears in the series of episodes which describe the transition from one state to the other. Indeed, what could better disturb the stable situation of the beginning, which the efforts of all the participants tend to consolidate, if not precisely an event external not only to the situation but to the world itself?

A fixed law, an established rule: that is what immobilizes narrative. For the transgression of the law to provoke a rapid modification, supernatural forces must intervene; otherwise narrative may break down until a human arbiter perceives the break in the initial equilibrium.

[handwritten margin note: Necessity of ↓ of to narrative.]

Again, let us recall the "Second Calender's Tale": the calender finds himself in the princess' underground chamber; he might remain there as long as he likes, enjoying his companion and the delicate sweetmeats she serves him — but the tale would thereby perish. Fortunately there exists a ban, a rule: not to touch the genie's talisman. This is obviously what our hero will do at once; and the situation will thereby be all the more quickly modified in that the retributive figure is endowed with supernatural force: "No sooner was the talisman broken than the Palace shook to its very foundations. . . ." Or consider the "Third Calender's Tale": here the law is not to utter the name of God. By violating this law, the hero provokes the intervention of the supernatural: his boatman — "the man of bronze" — falls into the water. Later: the rule is not to enter a certain room; by transgressing it, the hero finds a horse who carries him up into the sky . . . Whereby the plot is amazingly advanced.

Each break in the stable situation is followed, in these examples, by a supernatural intervention. The marvelous element proves to be the narrative raw material which best fills this specific function: to afford a modification of the preceding situation, and to break the established equilibrium (or disequilibrium).

It must be added that this modification can be caused by other means; but they are less effective.

If the supernatural is habitually linked to the narrative of an action, it rarely appears in novels concerned only with psychological descriptions and analysis (the example of Henry James is not contradictory here). The relation of the supernatural to narration is henceforth clear: every text in which the supernatural occurs is a narrative, for the supernatural event first of all modifies a previous equilibrium — which is the very definition of narrative; but not every narrative includes supernatural elements, even though an affinity exists between them insofar as the supernatural achieves the narrative modification in the fastest manner.

We see, finally, how the social and the literary functions coincide: in both cases, we are concerned with a transgression of the law. Whether it is in social life or in narrative, the intervention of the supernatural element always constitutes a break in the system of pre-established rules, and in doing so finds its justification.

Lastly, we may inquire as to the function of the fantastic itself: which is to say, not the function of supernatural events, but the function of the reactions that they provoke. This question seems all the more interesting because whereas the supernatural and the genre which accepts it literally, the marvelous, have always existed in literature and are much in evidence today, the fantastic has had a relatively brief life span. It appeared in a systematic way around the end of the eighteenth century with Cazotte; a century later, we find the last aesthetically satisfying examples of the genre in Maupassant's tales. We may encounter examples of the hesitation characteristic of the fantastic in other periods, but it is exceptional when this hesitation is thematized by the text itself. Is there a reason for this short span? Or again: why does the literature of the fantastic no longer exist?

In order to answer these questions, we must examine more closely the categories which have permitted us to

describe the fantastic. The reader and the hero, as we have seen, must decide if a certain event or phenomenon belongs to reality or to imagination, that is, must determine whether or not it is real. It is therefore the category of the real which has furnished a basis for our definition of the fantastic.

No sooner have we become aware of this fact, than we must come to a halt — amazed. By its very definition, literature bypasses the distinctions of the real and the imaginary, of what is and of what is not. One can even say that it is to some degree because of literature and art that this distinction becomes impossible to sustain. The theoreticians of literature have said as much many times over. For example, Blanchot: "Art is and is not, real enough to become the path, too unreal to become an obstacle. Art is an *as if*." And Northrop Frye: "Literature, like mathematics, drives a wedge between the antithesis of being and non-being that is so important for discursive thought. . . . Hamlet and Falstaff neither exist nor do not exist."

Even more generally, literature contests any presence of dichotomy. It is of the very nature of language to parcel out what can be said into discontinuous fragments; a name, in that it selects one or several properties of the concept it constitutes, excludes all other properties and posits the antithesis: *this* and *the contrary*. Now literature exists by words; but its dialectical vocation is to say more than language says, to transcend verbal divisions. It is, within language, that which destroys the metaphysics inherent in all language. The nature of literary discourse is to *go beyond* — otherwise it would have no reason for being; literature is a kind of murderous weapon by which language commits suicide.

But if this is the case, is that kind of literature that is based on language oppositions such as real/unreal, still literature?

Matters are, in truth, more complex: by the hesitation it engenders, the fantastic questions precisely the existence of an irreducible opposition between real and unreal. But in

order to deny an opposition, we must first of all acknowledge its terms; in order to perform a sacrifice, we must know what to sacrifice. Whence the ambiguous impression made by fantastic literature: on the one hand, it represents the quintessence of literature, insofar as the questioning of the limit between real and unreal, proper to all literature, is its explicit center. On the other hand, though, it is only a propaedeutics to literature: by combating the metaphysics of everyday language, it gives that language life; it must start from language, even if only to reject it.

If certain events of a book's universe explicitly account for themselves as imaginary, they thereby contest the imaginary nature of the rest of the book. If a certain apparition is only the fruit of an overexcited imagination, then everything around it is real. Far from being a praise of the imaginary, then, the literature of the fantastic posits the majority of a text as belonging to reality — or, more specifically, as provoked by reality, like a name given to a pre-existing thing. The literature of the fantastic leaves us with two notions: that of reality and that of literature, each as unsatisfactory as the other.

The nineteenth century transpired, it is true, in a metaphysics of the real and the imaginary, and the literature of the fantastic is nothing but the bad conscience of this positivist era. But today, we can no longer believe in an immutable, external reality, nor in a literature which is merely the transcription of such a reality. Words have gained an autonomy which things have lost. The literature which has always asserted this other vision is doubtless one of the agencies of such a development. Fantastic literature itself — which on every page subverts linguistic categorizations — has received a fatal blow from these very categorizations. But this death, this suicide generates a new literature. Now, it would not be too presumptuous to assert that the literature of the twentieth century is, in certain sense, more purely "literature" than any other. This must not of course be taken

as a value judgment: it is even possible that precisely because of this fact, its quality is thereby diminished.

What has become of the narrative of the supernatural in the twentieth century? For the answer, let us turn to what is doubtless the most famous text that may be placed in this category: Kafka's "Metamorphosis." The supernatural event is reported here in the first sentence of the text: "As Gregor Samsa awoke one morning from uneasy dreams he found himself transformed in his bed into a gigantic insect. . . ." There are, subsequently, a few brief indications of a possible hesitation. Gregor at first thinks he is dreaming; but he is quickly convinced of the contrary. Nonetheless, he does not immediately stop seeking a rational explanation: we are told that he "looked forward eagerly to seeing this morning's delusions gradually fall away. That the change in his voice was nothing but the precursor of a severe chill, an occupational hazard of travelling salesmen, he had not the least possible doubt."

But these succinct indications of hesitation are drowned in the general movement of the narrative, in which the most surprising thing is precisely the absence of surprise with regard to the unheard-of event that has befallen Gregor Samsa quite as in Gogol's "Nose" ("We shall never be sufficiently amazed about this lack of amazement," Camus once said apropos of Kafka). Gradually, Gregor accepts his situation as unusual but, after all, possible. When the chief clerk from his office comes to call for him, Gregor is so annoyed that he wonders "if something like what had happened to him today might some day happen to the chief clerk; one really could not deny that it was possible." He begins to find a certain consolation in this new condition which liberates him from all responsibility and makes others concern themselves about him: "If they were horrified then the responsibility was no longer his and he could stay quiet. But if they took it calmly, then he had no reason either to be upset. . . ." Resignation then seizes him: he concludes "that he must lie low for the present and,

by exercising patience and the utmost consideration, help the family to bear the inconvenience he was bound to cause them in his present condition.''

All these sentences seem to refer to a perfectly possible event — to a broken ankle for instance — and not to the metamorphosis of a man into a cockroach. Gregor gradually grows accustomed to the notion of his animality: first of all physically, by refusing human food and human pleasures; but also mentally: he can no longer trust his own judgment to determine if a cough is or is not human; when he suspects his sister of trying to remove a picture on which he likes to lie, he is ready to "fly in Grete's face."

It is no longer surprising, at this point, to find Gregor also resigning himself to the notion of his own death, so greatly desired by his family. "He thought of his family with tenderness and love. The decision that he must disappear was one that he held to even more strongly than his sister, if that were possible."

The family's reaction follows an analogous development: first there is surprise but not hesitation; then comes the immediately declared hostility on the father's part. Even in the first scene, "pitilessly, Gregor's father drove him back, hissing and crying 'Shoo!' like a savage," and in thinking this over, Gregor admits to himself "that he had been aware from the very first day of his new life that his father believed only the severest measures suitable for dealing with him." His mother continues to love him, but she is quite powerless to help him. As for his sister, early in the story the closest member of his family, her attitude changes to resignation, and at the end she has come to feel outright hatred. And here is how she summarizes the feelings of the entire family when Gregor is close to dying: "We must try to get rid of it. We've tried to look after it and to put up with it as far as is humanly possible, and I don't think anyone could reproach us in the slightest." If at first the metamorphosis of Gregor (who had been their sole source of income) dis-

tressed his family, gradually it is discovered to have a positive effect: the others begin to work again, they waken to life:

> Leaning comfortably back in their seats, they canvassed their prospects for the future, and it appeared on closer inspection that these were not at all bad, for the jobs they had got, which so far they had never really discussed with each other, were all three admirable and likely to lead to better things later on.

And the note on which the story ends is that "climax of the horrible," as Blanchot calls it, the sister's wakening to a new life: pleasure.

If we approach this narrative with the categories previously elaborated, we see that it is sharply distinguished from the traditional fantastic stories. First of all, the uncanny event does not appear following a series of indirect indications, as the climax of a gradation: it is contained in the very first sentence. The fantastic started from a perfectly natural situation to reach its climax in the supernatural. "The Metamorphosis" starts from a supernatural event, and during the course of the narrative gives it an increasingly natural atmosphere — until at the end, the story has gone as far as possible from the supernatural. Thereby all hesitation becomes useless: its function had been to prepare the way for the perception of the unheard-of event, and to characterize the transition from natural to supernatural. Here, it is a contrary movement which is described: that of *adaptation*, which follows the inexplicable event and which characterizes the transition from the supernatural to the natural. Hesitation and adaptation designate two symmetrical and converse processes.

Furthermore, we cannot say that, because of the absence of hesitation, even of astonishment, and because of the presence of supernatural elements, we find ourselves in another familiar genre: the marvelous. The marvelous implies that we are plunged into a world whose laws are totally different from what they are in our own and in consequence that the

supernatural events which occur are in no way disturbing. On the other hand, in "The Metamorphosis," it is indeed a shocking, impossible event which concerns us, but it is an event which ends by becoming possible, paradoxically enough. In this sense, Kafka's narratives relate both to the marvelous and to the uncanny; they are the coincidence of two apparently incompatible genres. The supernatural is given, and yet it does not cease to seem inadmissible to us.

At first glance we are tempted to attribute an allegorical meaning to "The Metamorphosis." But as soon as we try to make this meaning specific, we come up against a phenomenon very similar to the one we observed with regard to Gogol's "Nose" (the resemblance of the two narratives does not stop there, as Victor Erlich has recently shown). One might certainly suggest several allegorical interpretations of the text; but the text itself offers no explicit indication which would confirm any one of them. It is often said of Kafka that his narratives must be read above all *as narratives*, on the literal level. The event described in "The Metamorphosis" is quite as real as any other literary event.

It must be noted here that the best science fiction texts are organized analogously. The initial data are supernatural: robots, extraterrestrial beings, the whole interplanetary context. The narrative movement consists in obliging us to see how close these apparently marvelous elements are to us, to what degree they are present in our life. "The Body," a story by Robert Scheckley, begins with the extraordinary operation of grafting an animal's body to a human brain. At the end, it shows us all that the most normal man has in common with the animal. Another story begins with the description of an incredible organization which provides a service for "eliminating" undesirable persons. When the narrative ends, we realize that such an idea is quite familiar. Here it is the reader who undergoes the process of adaptation: at first confronted with a supernatural event, he ends by acknowledging its "naturalness."

What does such a narrative structure signify? In the fantastic, the uncanny or supernatural event was perceived against the background of what is considered normal and natural; the transgression of the laws of nature made us even more powerfully aware of them. In Kafka, the supernatural event no longer provokes hesitation, for the world described is entirely bizarre, as abnormal as the very event to which it affords a background. We therefore find here (but in an inverted form) the problem of the literature of the fantastic — a literature which postulates the existence of the real, the natural, the normal, in order to attack it subsequently — but Kafka has managed to transcend this problem. He treats the irrational as though it were part of a game: his entire world obeys an oneiric logic, if not indeed a nightmare one, which no longer has anything to do with the real. Even if a certain hesitation persists in the reader, it ceases to affect the character; and identification, as we have previously noted it, is no longer possible. The Kafkaesque narrative abandons what we had said was the second condition of the fantastic and the one that more particularly characterizes the nineteenth-century examples: the hesitation represented within the text.

Sartre has proposed, with regard to the novels of Blanchot and Kafka, a theory of the fantastic which is very close to what we have just suggested. It is to be found in his article on Blanchot's *récit*, "*Aminadab*, or the fantastic considered as a language," in *Situations*. According to Sartre, Blanchot and Kafka no longer try to depict extraordinary beings; for them,

> there is now only one fantastic object: man. Not the man of religions and spiritualisms, only half committed to the world of the body, but man-as-given, man-as-nature, man-as-society, the man who takes off his hat when a hearse passes, who kneels in churches, who marches behind a flag.

The "normal" man is precisely the fantastic being; the fantastic becomes the rule, not the exception.

.

This metamorphosis will have consequences for the technique of the genre. If previously the hero with whom the reader identifies was a perfectly normal being (so that the identification could be easy and so that we could be astonished with him by the uncanny nature of events), here it is this same central character who becomes "fantastic." Thus, in the case of the hero of *The Castle*: "Of this surveyor whose adventures and views we are to share, we know nothing but this unintelligible persistence in remaining in a forbidden village." The consequence is that the reader, if he identifies with the character, excludes himself from reality. "And our reason, which was to right the topsy-turvy world, swept into this nightmare, becomes itself fantastic."

With Kafka, we are thus confronted with a *generalized fantastic* which swallows up the entire world of the book and the reader along with it. Here is a particularly clear example of this new fantastic, which Sartre improvises to illustrate his notion:

> I sit down in a café, I order a light coffee, the waiter makes me repeat my order three times, and repeats it himself in order to avoid any chance of a mistake. He rushes off, transmits my order to a second waiter, who scribbles it in a notebook and transmits it to a third. Finally a fourth waiter appears and says: "Here you are," setting an inkwell down on my table. "But," I say, "I ordered a light coffee." "And here you are," he says as he walks away. If the reader supposes, reading tales of this sort, that what has occurred is no more than a trick played by the waiters or some collective psychosis [as Maupassant tried to persuade us in "Le Horla," for example], we have failed. But if we have been able to give the reader the impression that we are speaking to him of a world in which these preposterous manifestations figure as normal behavior, then he will find himself plunged at one fell swoop into the heart of the fantastic.

Here in a word is the difference between the fantastic tale in its classic version and Kafka's narratives: *what in the first world was an exception here becomes the rule.*

Let us say in conclusion that by this rare synthesis of the supernatural with literature as such, Kafka affords us a better understanding of literature itself. We have already evoked literature's paradoxical status a number of times: it lives only by what ordinary language calls, for its part, contradictions. Literature embraces the antithesis between the verbal and the transverbal, between the real and the unreal. Kafka's *oeuvre* permits us to go further and to see how literature brings into being another contradiction within itself. This further contradiction is formulated in a meditation upon this *oeuvre*, Blanchot's essay "Kafka and Literature." A common and simplistic view presents literature (and language too) as an image of "reality," as a tracing of what is not itself, a kind of parallel and analogous series. But this view is doubly false, for it betrays the nature of the utterance as well as the nature of the act of uttering. Words are not labels pasted to things that exist as such independently of them. When we write, we do merely that — the importance of the gesture is such that it leaves room for no other experience. At the same time, if I write, I write about something, even if this something is writing. For writing to be possible, it must be born out of the death of what it speaks about; but this death makes writing itself impossible, for there is no longer anything to write. Literature can become possible only insofar as it makes itself impossible. Either what we say is actually here, in which case there is no room for literature; or else there is room for literature, in which case there is no longer anything to say. As Blanchot writes in *La Part du Feu*: "If language, and in particular literary language, were not constantly advancing toward its death, it would not be possible, for it is this movement towards its impossibility which is its condition and its basis."

The operation which consists of reconciling the possible with the impossible accurately illustrates the word "impossible" itself. And yet literature *exists*; that is its greatest paradox.

September, 1968

index